WITHDRAWN

100 WAYS TO TAKE BETTER PHOTOGRAPHS

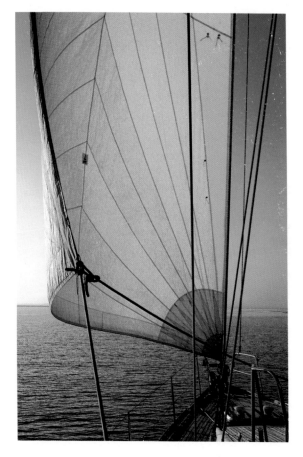

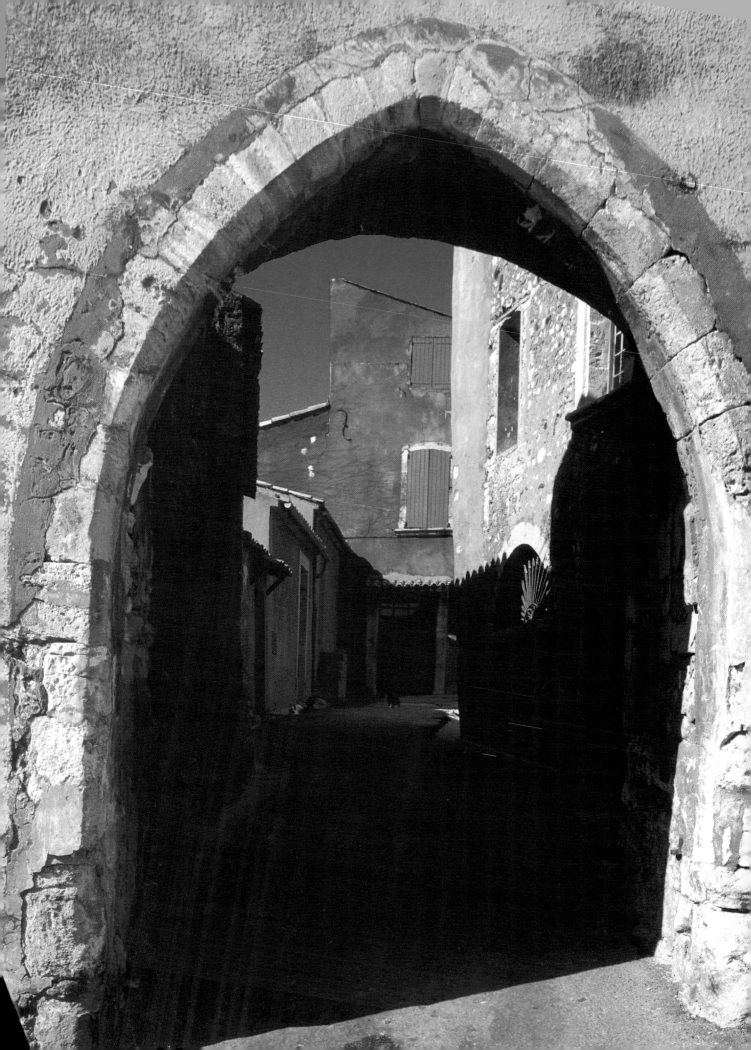

100 WAYS TO TAKE BETTER PHOTOGRAPHS

MICHAEL BUSSELLE

David & Charles

A DAVID & CHARLES BOOK

First published in the UK in 2003

Reprinted 2005

Copyright © Michael Busselle 2003

Distributed in North America
by F&W Publications, Inc.
4700 East Galbraith Road
Cincinnati, OH 45236
1-800-289-0963

Michael Busselle has asserted his right to be identified as author of
this work in accordance with the Copyright, Designs and Patents
Act, 1988.

All rights reserved. No part of this publication may be reproduced,
stored in a retrieval system, or transmitted, in any form or by any
means, electronic or mechanical, by photocopying, recording or
otherwise, without prior permission in writing from the publisher.

A catalogue record for this book is available from the British Library.

ISBN 0 7153 1499 8

Printed in China by SNP Leefung
for David & Charles
Brunel House Newton Abbot Devon

Senior Editor Freya Dangerfield
Art Editor Sue Cleave
Designer Nigel Morgan
Production Controller Kelly Smith

Visit our website at www.davidandcharles.co.uk

David & Charles books are available from all good bookshops;
alternatively you can contact our Orderline on (0)1626 334555 or
write to us at FREEPOST EX2110, David & Charles *Direct*, Newton
Abbot, TQ12 4ZZ (no stamp required UK mainland).

Contents

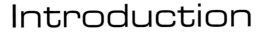

Introduction

It's never been easier to take a photograph than it is today. Anyone who can hold a camera, point it in the right direction and press a button can do it. But taking a good photograph requires a little more thought. Very often you need spend only a moment or two to make the difference between taking yet another uninteresting snapshot or producing an eye-catching photograph. The aim of this book is to describe and illustrate the most frequently encountered situations where a little more thought and care can make that difference.

Knowing your camera and understanding how to use it effectively are the first steps towards improving your photography, and chapter one explains how to use the camera's functions and controls to the best advantage. Chapter two shows how each of the most widely used accessories can help you to take more interesting and better quality photographs.

Taking better photographs has as much to do with the choice of subjects and the ability to recognize their visual potential as it has with equipment and technique...

Taking better photographs has as much to do with the choice of subjects and the ability to recognize their visual potential as it has with equipment and technique, and chapter three describes and illustrates how to make your images more telling through good composition. Light makes photographs, and chapter four shows how to be aware of its qualities and how to make the best use of them.

Taking good colour photographs involves more than simply loading your camera with colour film, and chapter five deals with the ways in which you can use colour to produce images with impact. Chapter six suggests ways to take striking photographs of people that will have a much wider interest and appeal than most of those in the family album.

Capturing the beauty of nature is one of the greatest challenges in photography, and chapter seven shows you how to focus interest on the key elements and photograph animals and plants in the most telling ways. While most photographs are of subjects at a distance from the camera, chapter eight demonstrates how taking a much closer look can create intriguing images from everyday objects.

Probably more photographs are taken while people are travelling or on holiday than at any other time, but it's all too easy to come home with pictures that reflect little of your experience or the essence of your destination. Chapter nine illustrates how you can take evocative photographs with a real sense of place. Of all photographic subjects, the landscape is perhaps the most inspirational, but it is one of the most elusive to capture successfully on film. Chapter ten shows how to see the true potential of the countryside in visual terms, and how to take photographs that are more than just records of beautiful views.

With all the latest technology built into today's cameras, and the bewildering choice of equipment which is available, photography can seem somewhat daunting. It helps, of course, to be familiar with your camera and to understand its basic functions but, ultimately, it is observation, planning and imagination which make good photographs. A simple camera used with a keen eye and a positive approach will always produce better photographs than the most advanced equipment in the hands of those who lack these qualities.

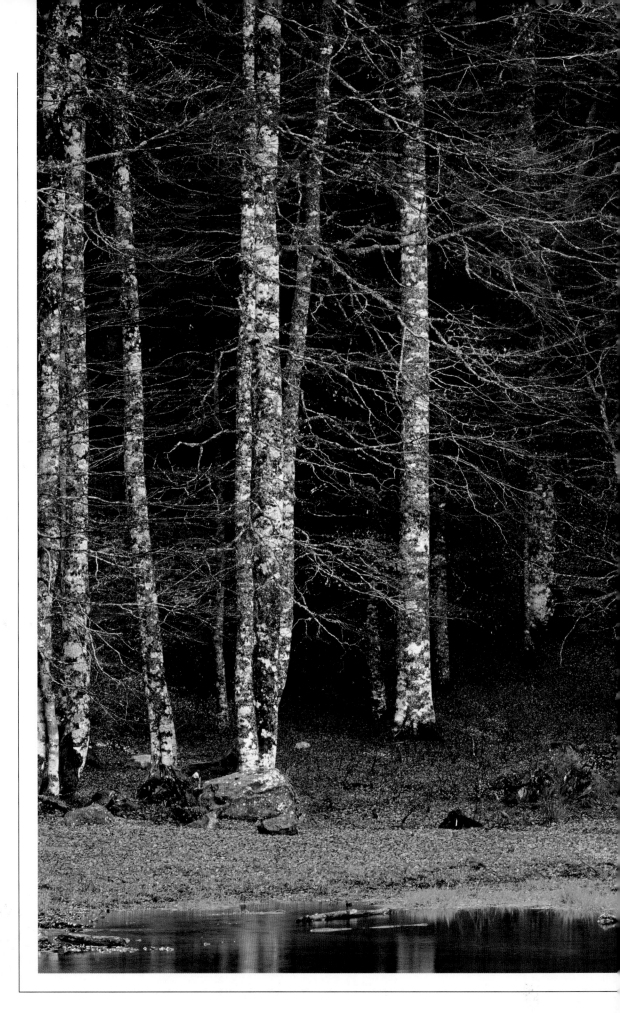

Camera craft

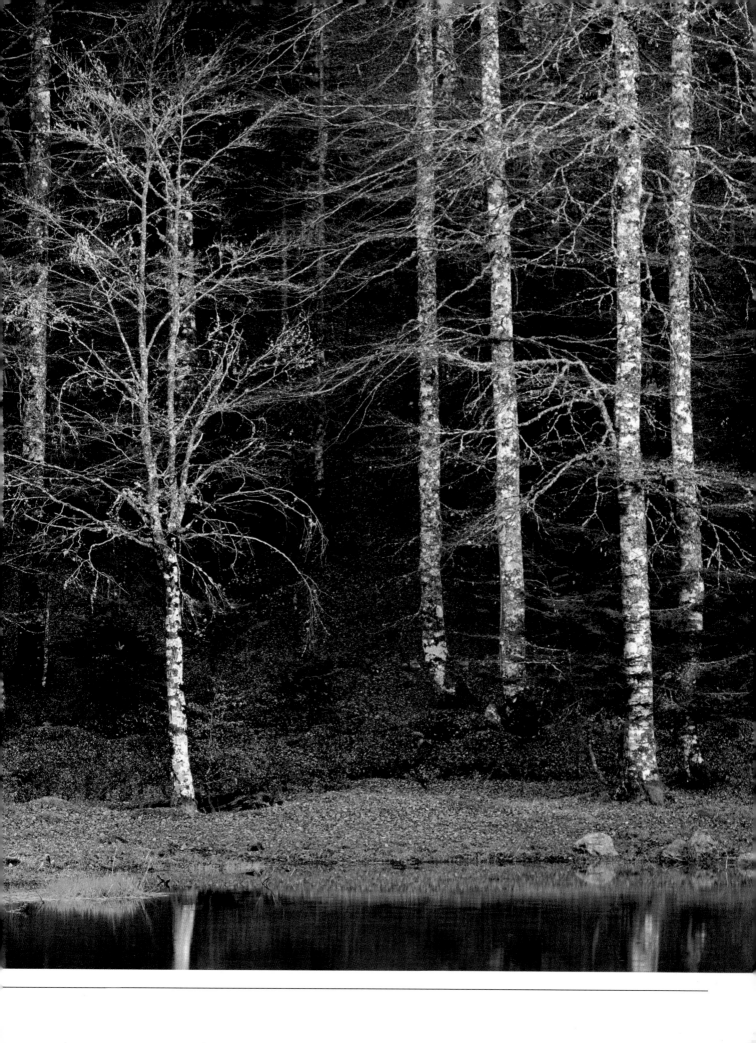

1 Take sharper photographs

Most modern camera lenses are capable of producing pin-sharp images if you take care to avoid camera shake. The surest way to achieve the bite and clarity that will make an image stand out is to use a tripod, but it's not always convenient to carry one. Learn how to hold the camera steady and release the shutter smoothly, especially in the less stable upright position, and if possible, brace yourself or the camera against a solid support. Shutter speed is also important. Many consider 1/125 sec a 'safe' speed, and with a standard or wide-angle lens focused at a fairly distant object it probably is. But when a longer focal length lens is used, or when the focusing distance is closer, 1/250 or 1/500 sec is a much safer bet.

Samburu girl

first view I met this young girl, dressed in the traditional clothes of her tribe, in a village in Kenya. Although the day was bright and sunny, she was standing in an area of shade, which created a pleasingly soft light but with much reduced intensity.

in camera I did not want to set up my tripod as I thought it might make her too self-conscious, but I was concerned about avoiding camera shake as I wanted to frame her quite tightly using a long-focus lens. My camera was loaded with ISO 100 film. By setting the widest aperture of f/2.8 I found that I could use a shutter speed of 1/500 sec, which proved to be fast enough to record a sharp image.

35mm SLR camera; 70–200mm zoom lens; Fuji Provia 100F

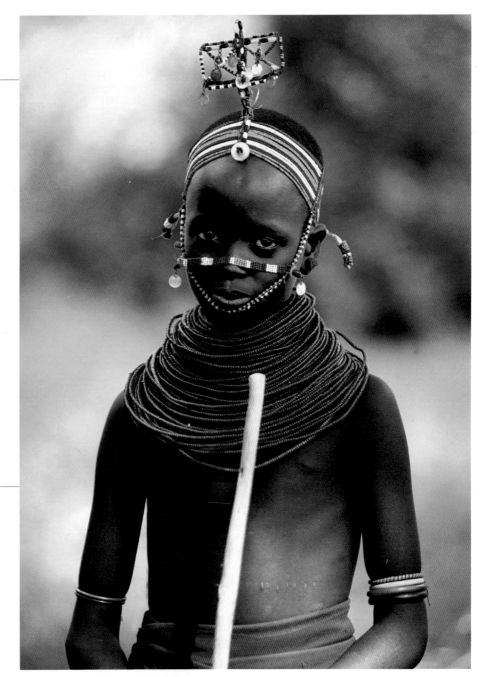

2 Look at the edges of the viewfinder

It's easy to think of the viewfinder as simply a means of aiming the camera, but it's much more creative to think of it as the photographer's 'canvas', a space to be filled in the most pleasing and striking way possible. If you use it only as an aiming device, the result will often be a picture with a centrally placed subject, surrounded by unnecessary and uninteresting details. By looking first at the edges of the frame, you will become much more aware of the full scope of the image, and can decide if there are objects or details which would be best left out of the picture. At the same time, by angling the camera in different ways, you can choose where it is best to place the main focus of interest of the image within the frame.

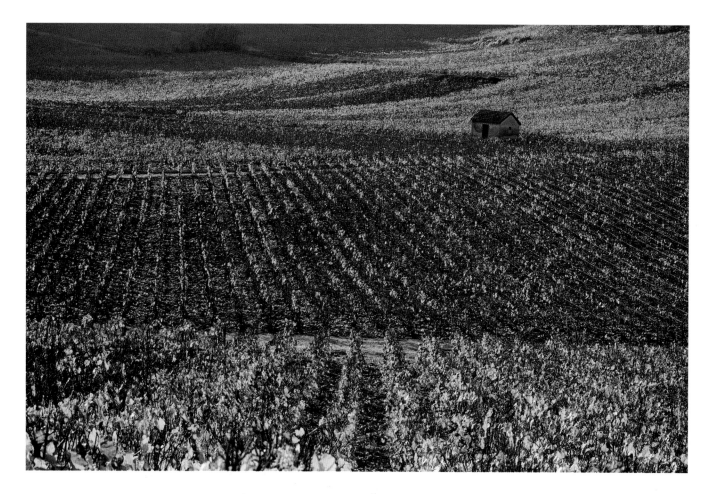

Champagne vineyards

first view Travelling through wine-growing country in late autumn is a very enjoyable experience, as the vine leaves take on a wide range of spectacular colours. I spotted this scene in the Champagne region of France in the late afternoon, when the sunlight was glancing across the vines at an acute angle.

in camera I found a viewpoint that enabled me to look down onto the vineyard, and used a wide-angle lens to include a large area of the golden foliage. The small hut provided an essential focus of interest and I angled the camera in several different ways before I decided that placing it near the top right-hand corner of the frame produced the most balanced effect.

Medium format SLR camera; 55–110mm zoom lens; Fuji Velvia

3 Make use of depth of field

Depth of field describes the area, behind and in front of the point at which the camera is focused, that is acceptably sharp. With a long-focus lens set to a wide aperture, the depth of field is very shallow, while with a wide-angle lens set to a small aperture the image can be sharp from front to back. Subjects such as landscapes, which have both close foreground and distant details, need the greatest possible depth of field to make the image sharp throughout. Using the camera's depth-of-field preview button will help you choose the correct aperture, but when maximum depth of field is needed it's best to use the smallest available aperture and focus at a point about one third of the way between the nearest and furthest details.

Yosemite

first view Like millions of other photographers, I wanted to go home with a photograph of this famous landmark in the Yosemite National Park in California. The afternoon sunlight was sharp and clear, but my first composition looked a little bland, and I felt the need to create more impact through a better choice of viewpoint.

in camera I went down to the river bank and clambered across the rocks until I found this striking boulder and clump of grass. Placing the camera quite low down and close to these two features produced a strong foreground, but they needed to be as sharp as the distant rock face. I set the smallest aperture of f/16, using a wide-angle lens, and focused at a point on the far bank to obtain the maximum depth of field.

35mm SLR camera; 24–85mm zoom lens with polarizing and 81B warm-up filters; Fuji Velvia

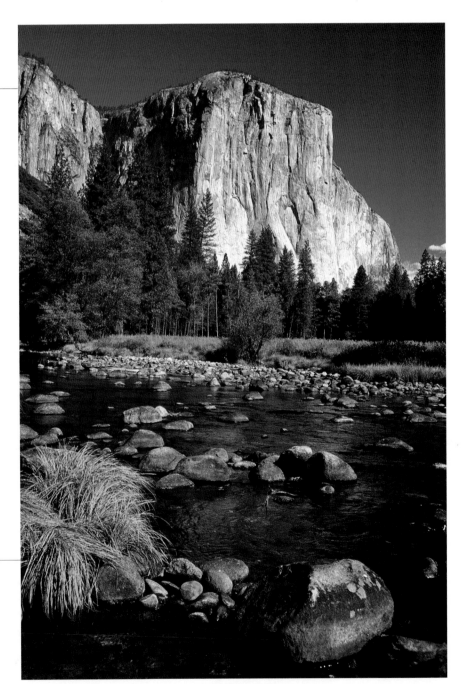

4 Use a wide aperture to isolate the subject

One of the facilities that is especially valuable in photography, but often not fully appreciated, is the ability to draw attention to specific parts of a scene or subject by exploiting the difference between sharply focused and unfocused areas. This is especially useful when photographing people or animals against a fussy or distracting background that cannot be avoided. If you select a wide aperture, the depth of field will be quite limited. Provided there is some distance between the subject and the background, the latter will appear as a blur, subduing even quite intrusive background details. The effect is greater when a long-focus lens is used, and when the subject is quite close to the camera.

Frenchman

first view I spotted this jovial Frenchman while wandering around a country market and thought that he would make a good subject for an unposed portrait. The surroundings were rather busy, with many people and the clutter of market stalls, and I wanted to make sure that he would be well separated from the distracting background.

in camera I moved to a viewpoint that placed the least fussy area of the surroundings behind my intended target, and edged my way as close as I could to him without attracting his attention. I waited until his gaze was directed elsewhere and focused on his eyes and mouth, using a long-focus lens set to the maximum aperture of f/2.8, before making my exposure.

35mm SLR camera; 70–200mm zoom lens; Fuji Provia 100F

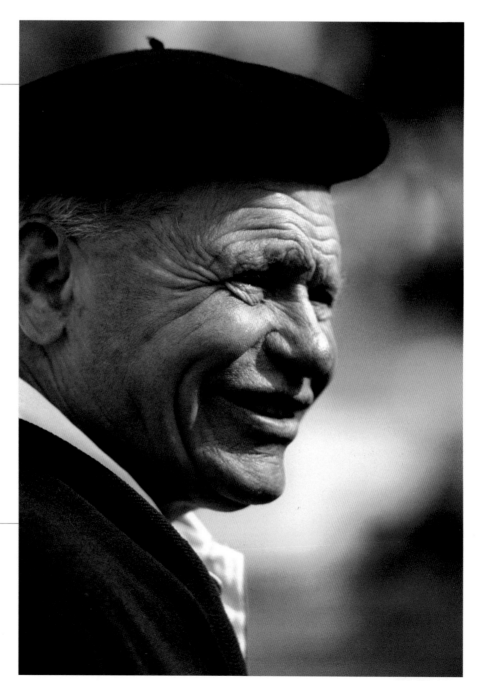

5 Use exposure compensation

Exposure determines how light or dark an image is. When you are shooting on negative film it is possible to control the final density of the image at the printing stage, but with transparency film you need to use exactly the right exposure at the time of shooting to create the effect you want. If you want to make an accurate record of a subject, such as a painting, the correct exposure is one that records all the colours accurately. But with photographs taken for purely aesthetic purposes, the correct exposure is the one that creates the effect you want. Giving more exposure makes the image lighter and the colours softer, whereas giving less exposure produces more dramatic tones and richer colours.

Wet cobbles

first view A rainy day in Paris can have some compensations, not least the attractive reflections created on wet, shiny cobbles. I spotted this leaf-strewn expanse of old cobblestones in a courtyard off the Place des Vosges and, although it was overcast and dull, the sparkling reflections created a bright and lively image.

in camera I used a wide-angle lens in order to include a large area of the cobbles while aiming the camera down quite steeply to give an almost bird's eye view. I chose a viewpoint and framed the image to make the most of the pattern created by the leaves and highlights. I gave one stop less exposure than the camera's meter indicated, as I wanted the image to have rich tones that would emphasize the highlights and texture of the stones.

35mm SLR camera; 17–35mm zoom lens; digital capture at ISO 400 setting

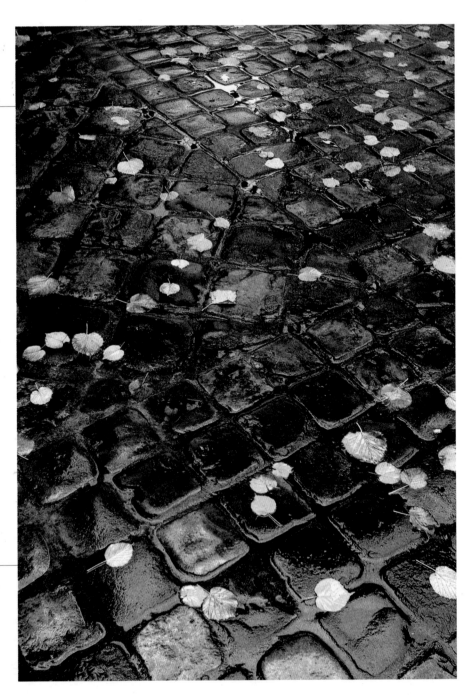

6 Bracket your exposures

Judging the right exposure for a particular effect can be difficult when using transparency film, as a number of variables make it hard to predict the result accurately. One camera's metering system can be different from another, and there can be variations in the stated shutter speeds. The age of the film may affect its speed, and when and where it is processed can also influence the result. Together, these factors could result in effective exposure variations of as much as half a stop, with a marked effect on the quality of the transparency. The best way to ensure that you get exactly the result you want is to bracket exposures, by giving one or two extra exposures each side of that indicated, varying each by half or one third of a stop.

Sunset

first view I watched this lovely sunset develop while on a beach in the south of Spain, and found a viewpoint where the reflected colours on the wet sand occupied most of the foreground. I waited until the sun had lost some of its power, as when I first arrived there was too much contrast.

in camera I fitted a neutral-graduated filter to make the sky darker and bring it into better balance with the foreground, and then took a general exposure reading. Sunsets can be especially difficult to predict in exposure terms: to enhance the colour saturation I wanted to give the minimum exposure, though without the image looking muddy. Too little exposure would have rendered the colours overblown and crude, but too much would have made them look weak and lacking in impact. I bracketed exposures in increments of one third of a stop. The images here show the effect of two thirds under- and overexposure, compared with the one I selected.

35mm SLR camera; 20–35mm zoom lens with neutral-graduated filter; Fuji Velvia

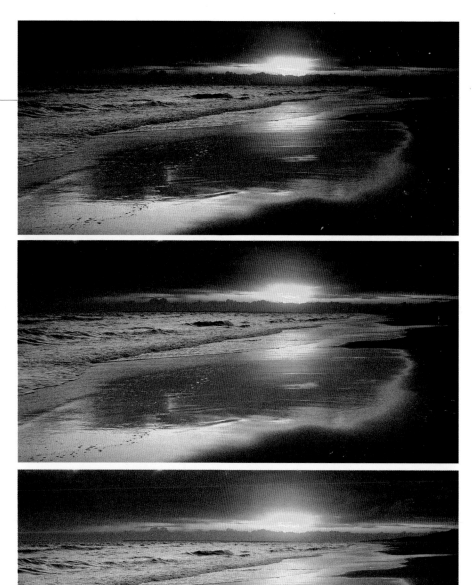

7 Use a fast shutter speed to freeze movement

If you want to achieve a sharp photograph of a moving subject, it is necessary to freeze the movement by using a fast shutter speed. The shutter speed needed to do this depends upon both the speed and direction of the subject, as well as its distance from the camera. A shutter speed of only 1/125 sec might be enough to create a sharp image of a person some distance away, walking towards the camera, but if your subject is a fast car travelling across the camera's view, you might need 1/2000 sec or less to freeze the movement completely. As it is difficult to judge these factors objectively, the best and simplest course is to set the fastest speed that the lighting conditions and film speed will allow.

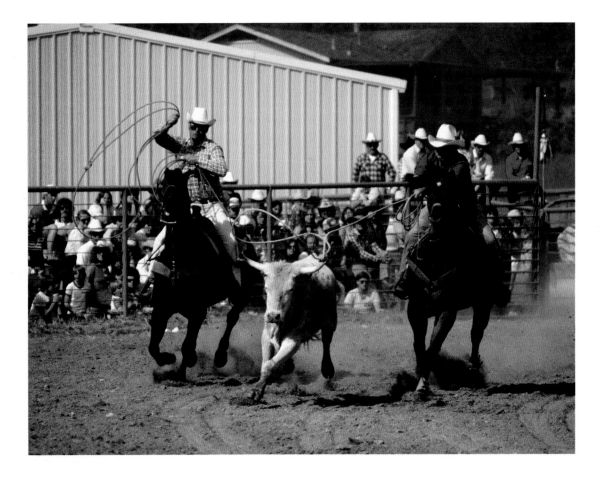

Rodeo

first view I came across a village festival while travelling through California, and the highlight of the week's celebrations was a rodeo. It was not a big affair and there was a very friendly, informal atmosphere, which meant I had some freedom to wander around and was able to try different viewpoints. This event involved roping a young steer, which was let loose from a cage. The action was very unpredictable, and it was usually all over in a very short time.

in camera After watching a few attempts to catch an animal, I chose a viewpoint that I thought would give me a clear view of the action and provide the least intrusive background. I had my camera aimed and focused at the exit point, with the shutter speed set to the fastest the film and light would allow, 1/500 sec, and waited until the best opportunity presented itself before making the exposure.

35mm SLR camera; 300mm lens; Kodak High Speed Ektachrome

8 Use a slow shutter speed to show movement

Exploiting the way the photographic medium deals with movement can be an interesting and effective way of creating an eye-catching image. Like all the camera's controls, the choice of shutter speed can make a significant difference to the quality and effect of a photograph, and those who simply set the camera mode to programme, leaving the shutter speed to be set automatically, are missing out on the opportunity to create some striking images. One of the most pleasing effects that can be achieved in this way is the use of a slow shutter speed to create blur with a moving subject. Fast-flowing water, such as a waterfall, can look especially effective when the camera is set on a tripod and a shutter speed of around 1 sec is set.

Blue water

first view I photographed this scene at Hardraw Force in the Yorkshire Dales, during the winter when there was a good flow of water. In the late afternoon, the orange-tinted sunlight was reflecting off the cliff face onto the surface of the water. It made a very striking contrast with the blue tint created in the shade.

in camera I chose a viewpoint that placed the most interesting section of the flowing water in the foreground, together with the rocks, and framed the image so that only the most important areas were included. With the camera set on a tripod, I set a small aperture with a shutter speed of about 2 sec.

Medium format SLR camera; 55–110mm zoom lens; Fuji Velvia

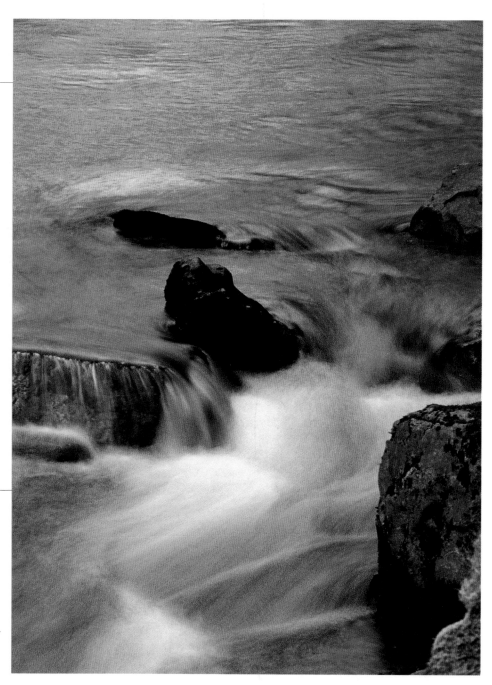

9 Use the right film

There is a vast choice of films available and they vary a great deal in the way they record images. When you are shooting in colour, you need to find a film that offers the colour balance and saturation that will suit the subjects you are photographing. Colour negative film is the obvious choice for those who want easily processed colour prints; colour transparency film needs more accurate exposure, but you have more control over the final results. You must also consider the film's speed. The higher this is, the more sensitive the film, allowing you to use faster shutter speeds and smaller apertures. But image quality declines as the speed increases: it is best to use the slowest film the lighting conditions and the subject will allow.

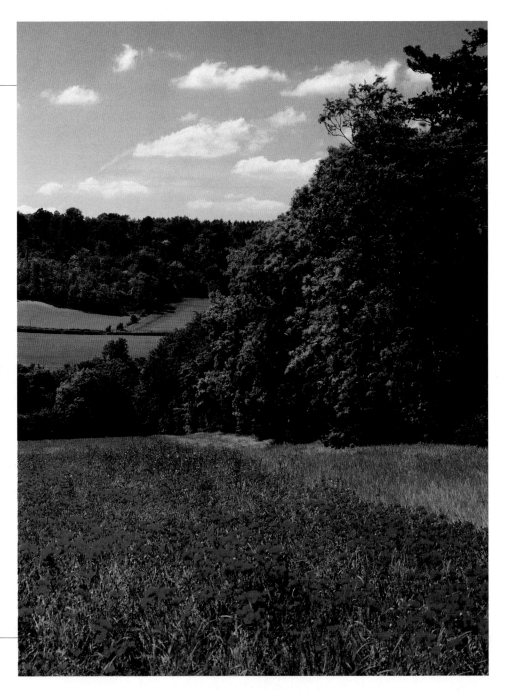

Poppy field

first view This valley is near my home and is a place I visit often. While shooting pictures for a book I thought this scene might be a suitable subject for the cover. I chose a viewpoint that placed the densest area of the flowers in the foreground, with the hill behind, and framed the image to include the trees, using the upright format with the shape of the book in mind. It was a static subject and I intended to use a tripod, which meant that I could choose a slow fine-grained film with good contrast and colour saturation, knowing that I could use a slow shutter speed without the risk of movement.

in camera I used both polarizing and warm-up filters in order to maximize the colour saturation and emphasize the rich red of the poppies, knowing that my film choice, Fuji Velvia, would enhance them further and that the printer would want to have a colour transparency to reproduce from.

Medium format SLR camera; 55–110mm zoom lens with 81B warm-up and polarizing filters; Fuji Velvia

10 Follow a shooting régime

Many of the best picture opportunities arise spontaneously and will be missed unless you are familiar and at ease with using your camera. If you watch a professional photographer working you will see that using the camera has become an instinctive and subconscious act. Even if you are only an occasional user, you can become similarly adept if you follow a regular routine each time you prepare to take a photograph. Mine is as follows:

1 As soon as the camera leaves the bag, check: the battery level, the ISO setting, the metering mode, and set the exposure compensation at zero.
2 Find the best viewpoint.
3 Roughly check framing and exposure˙settings.
4 Decide if exposure compensation or filters are needed.

5 Consider if the viewpoint or framing can be improved.
6 Check that you have set the best combination of shutter speed and aperture.
7 Check the camera is focused at the right spot.
8 Wait for the most opportune moment before shooting.

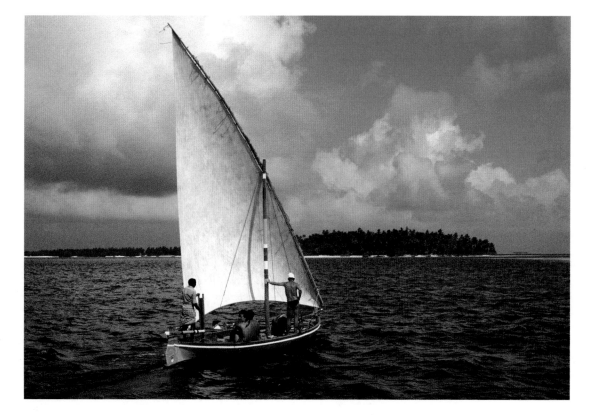

Maldive yacht

first view I was on a small boat travelling between some of the uninhabited Maldive Islands when I spotted this yacht some distance away, coming up behind us. I'd wanted to shoot a distant image of one of the islands but it needed some foreground interest and I thought this yacht might fit the bill.

in camera I realized that I would have only a brief opportunity as soon as the yacht passed, because it was moving quite swiftly and would be in the right position for only a few seconds. I prefocused the camera and checked the exposure, aiming it at the area I wanted to shoot. As soon as the yacht moved into the right spot, I made my exposure.

35mm SLR camera; 35–70mm zoom lens; Fuji Provia 100F

Lenses and accessories

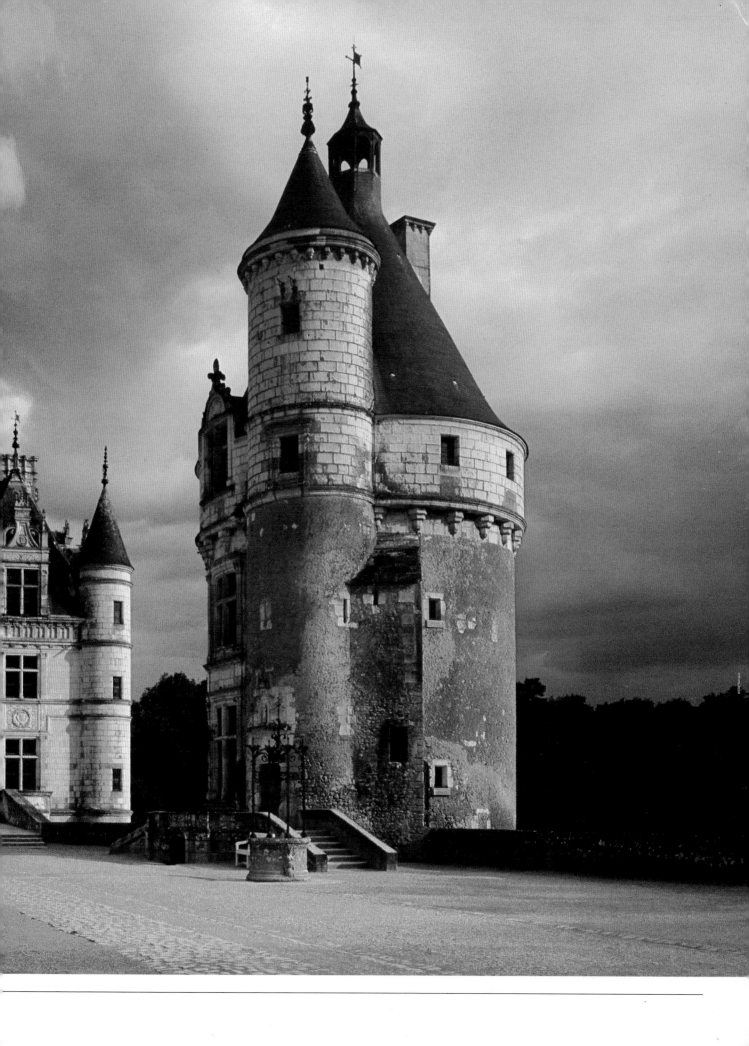

11 Use a warm-up filter

Colour transparency film is designed to be used under quite precise lighting conditions – sunlight in the middle of the day. But sunlight can be very much redder towards sunset, and in open shade under a blue sky the light will have a pronounced blue cast. Our eyes compensate for this colour variation, but it will be recorded faithfully on film. When the light is too red the results are usually quite pleasing, except that skin tones may look florid. But a blue cast is almost always unattractive, and warm-up filters, ranging from 81A (pale straw) to 81EF (orange), greatly improve pictures taken in this light. It's best to experiment, as the strength of filter needed depends on the film as well as the colour quality of the light and the subject.

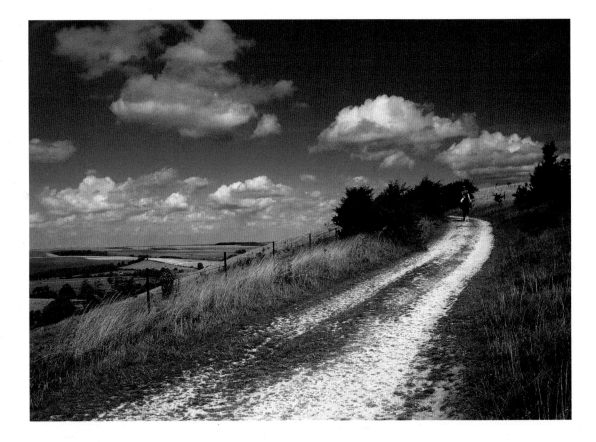

Win Green Hill

first view I was blessed with a perfect summer's day when I visited this beauty spot in Wiltshire. The sun was high and the sky a perfect blue, with nicely formed white clouds. I chose a viewpoint that placed the track running from the foreground diagonally into the picture, and framed the image to include the bushes on the right and all of the distant cloud bank on the left.

in camera I fitted a polarizing filter to intensify the blue sky and make the clouds stand out well, and added an 81B warm-up filter to ensure the midday sunlight and blue sky did not create a blue cast. The arrival of the horse and rider when I was ready to make the exposure was pure luck.

35mm SLR camera; 20–35mm zoom lens with polarizing and 81B warm-up filters; Fuji Velvia

12 Use a polarizing filter

A polarizing filter is one of the most useful to have in the camera bag. It can have a significant effect on the quality of your pictures, by eliminating some of the light reflected from non-metallic surfaces, such as foliage and water (including the water droplets in the atmosphere that are responsible for blue skies). The effect is controlled by rotating the filter and does not alter the colour balance of the image. It does require one and a half to two stops extra exposure, but this is allowed for when using TTL metering. A polarizing filter is most commonly used to make blue skies richer and darker, but it can also make water appear more translucent, and can greatly increase the colour saturation of foliage, even on a dull day.

Courthouse

first view The Arches National Park in Utah possesses some of the most dramatic rock formations to be seen anywhere and picture opportunities abound. I was most impressed with this massive stone face, which the clear sunlight was illuminating perfectly.

in camera I found a viewpoint that made the cliff tower above me and also showed a little of the distant snow-capped mountains. Fitting a polarizing filter not only made the sky a deeper, richer blue but also enhanced the colour of the stone and made the snow and clouds stand out more clearly.

35mm SLR camera; 24–85mm zoom lens with polarizing and 81A warm-up filters; Fuji Velvia

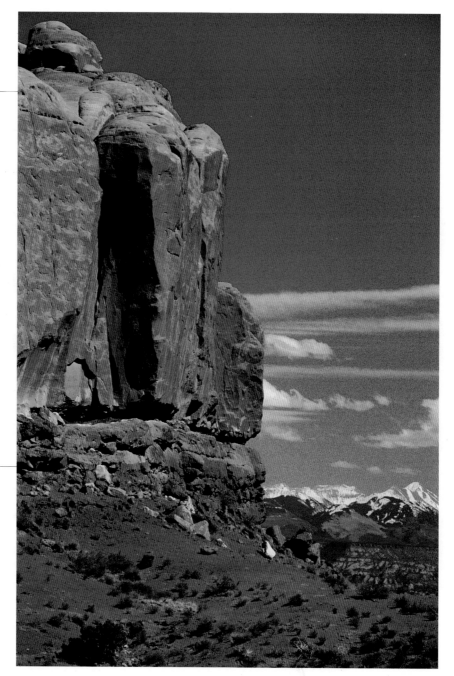

13 Use a neutral-graduated filter

One of the techniques most commonly used by photographers using black and white, when making prints, is to burn in the sky, giving it extra exposure to make it darker and richer. It's often necessary because the sky is part of the light source, and usually needs less exposure than the land. This effect can be created in the camera by using a neutral-graduated filter. It is tinted grey on one half, and becomes progressively clearer. The square filter is mounted on the lens in a holder that allows it to be moved up and down or from side to side. It's normally adjusted so that the gradation begins around the horizon, making the sky above progressively darker, but it can be used upside down to make a foreground darker, or on its side to adjust an imbalance in brightness on one side of the image. When it is used to correct the balance between a very bright sky and a darker foreground, the exposure need not be altered, but when used to make a normal sky darker you should set the exposure before fitting the filter.

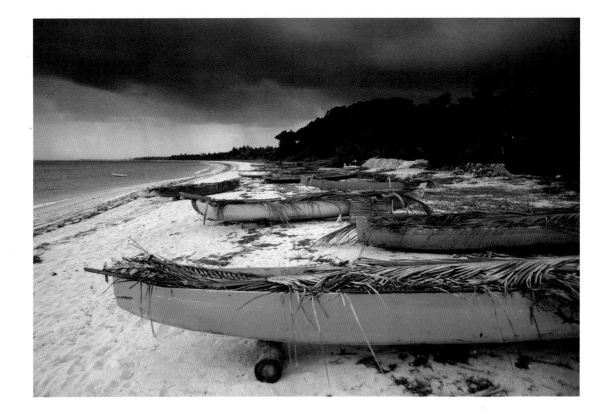

Blue boats

first view I saw these boats lined up on a beach in Bali on a day that was heavily overcast. I was attracted to the subject by the overall blueness of the scene and the dramatic, threatening sky.

in camera Using a wide-angle lens, I found a viewpoint that placed the nearest boat close up in the foreground, helping to create a strong sense of depth and distance. Although the sky was already quite dark, I decided to emphasize it further by fitting a neutral-graduated filter, setting my exposure first.

35mm SLR camera; 20–35mm zoom lens with neutral-graduated filter; Fuji Velvia

14 Use a red filter for black and white

In black-and-white photography, the ability to control the tonal quality of the image at the time a photograph is taken is extremely useful. Normal black-and-white film is sensitive to all the colours of the spectrum, so a colour filter will affect the way each colour is recorded on the film, and this can be used to create greater impact in a monochrome image. A scene that contains red, green and blue objects of similar brightness will record on black and white film as a number of more or less equal shades of grey, resulting in a photograph that lacks contrast and impact. However, if a blue filter is used the blue object will be much lighter while the other two will be darker. Similarly a red filter will make the red object lighter and the others darker, while a green filter will make the red and blue objects darker and the green one lighter. In landscape photography, the use of a red filter renders a blue sky as dark and dramatic, while the redder tones of the land are recorded as paler greys.

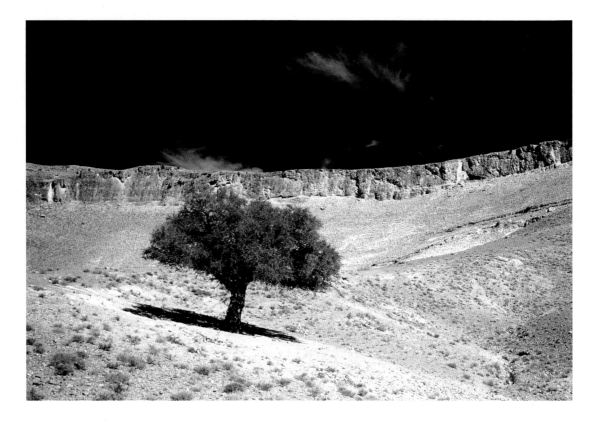

Moroccan tree

first view I saw this isolated tree set below a stony ridge as I drove over the Atlas mountains in Morocco. I liked its bold, simple shape and the way it leaned to one side, as well as the curving line of the cliff above it.

in camera This subject was quite satisfying as a colour image, as the sky was a strong blue and the stony ground had a reddish tint, but I thought it might have more impact in black and white. I fitted a deep red filter, which made the sky a much darker tone, with the ground recording as a very pale grey. The resulting increase in contrast helps to emphasize the shape of the tree.

35mm SLR camera; 24–85mm zoom lens with red filter; Ilford XP2

15 Use a wide-angle lens to exaggerate perspective

The effect of perspective in a photograph is one of the qualities that help to give an impression of depth and distance in an image, creating the illusion of a third dimension. The effect is created by the fact that objects that are close to the camera appear larger than distant ones of a similar size. The greater this difference is, the more noticeable the effect will be. A wide-angle lens allows you to include in a photograph objects and details that are very close to the camera, as well as distant elements. In this way it can exaggerate the perspective effect to a considerable degree. In landscape photography, foreground detail can be a useful way of giving your picture impact, and adding interest to the composition. When a wide-angle lens is used with a subject close to the camera, it will allow you to include a large area of background and hold both in sharp focus.

Mull of Kintyre

first view It had been a beautiful sunny day as I'd travelled around the Mull of Kintyre on the western Scottish coast, and I could see that there was likely to be a good sunset. I spent the last hour or so of the afternoon looking for a west-facing beach where I might find some interesting foreground details. I was attracted by these dark-toned boulders at the edge of the sea, especially the one in which the constant movement of small stones had ground a depression.

in camera I chose a viewpoint that placed the boulders quite close to the camera, and used a wide-angle lens in order to include the distant mountains on the Isle of Jura. I waited until the bright sunset had dimmed enough to record on film and used a neutral-graduated filter to reduce it further still.

35mm SLR camera; 24–85mm zoom lens with neutral-graduated filter; Fuji Velvia

16 Use a long-focus lens to compress perspective

The absence of close foreground objects when viewing a scene reduces the impression of perspective, and a tree some distance away will appear much closer to its true relative size in comparison with a similar one at twice the distance. Nothing seems odd about this when it is viewed normally, but if a small area of a distant scene is isolated with a long-focus lens the result can appear as if the distances between objects have become compressed, and the image seems two-dimensional. This is commonly seen when very long-focus shots are taken of sports action, when the crowd watching in the background of an arena, for example, can appear to be almost on top of the subject being photographed. Although the effect will not be so dramatic when a 200mm or 300mm lens is used, it can be, nonetheless, an effective way of creating images with a graphic quality and a rather different look.

Summer fields

first view This scene was photographed in the Aube region of France in the early summer, when crops planted on the open rolling hillsides still retained their fresh and vibrant colours, and were displaying a surprising variety of hues. The gentle contours of this farming countryside provided a variety of viewpoints, which I explored before settling on this one.

in camera My first inclination was to shoot a wider view of the scene, which would have included some trees and a farm track, but as I set up, I realized that by framing the image much more tightly with a long-focus lens I could produce an almost abstract effect by showing only bands of colour.

Medium format SLR camera; 300mm lens with polarizing and 81A warm-up filters; Fuji Velvia

17 Use a macro lens for close-ups

Most normal camera lenses will focus down to 1m (3ft) or less, and some have a macro setting that allows even closer focusing. A true macro lens can be focused closely enough on a subject to produce a life-size image on the film, and this opens up a whole new world of possibilities. Many everyday objects around the home and garden can provide exciting picture opportunities when viewed at very close quarters. It's also possible to focus at much closer distances with the aid of extension rings or bellows attachments. Supplementary, or close-up, lenses can be attached like filters to achieve a similar effect, but these may reduce definition unless a small aperture is used. The main points to consider when shooting very close-up images is that the depth of field will be very restricted, requiring the use of small apertures, and the risk of camera shake is greatly increased, making the use of a tripod essential.

Raindrops

first view Early morning rain had left the garden rather damp, and the fallen autumn leaves were spotted with raindrops when I went out. The sun had also begun to emerge and, though still weak, had created some attractive highlights. I spent a while searching for a combination of a nice-looking leaf and well formed droplets, before settling on this one.

in camera I had intended to include the whole of the leaf, using my macro lens from immediately above it, but this would have included too many distracting elements. I fitted an extension ring, which allowed me to move in closer and frame the image more tightly. I used a small aperture for maximum depth of field and mounted the camera on a tripod.

35mm SLR camera; 100mm macro lens with extension tube; Fuji Velvia

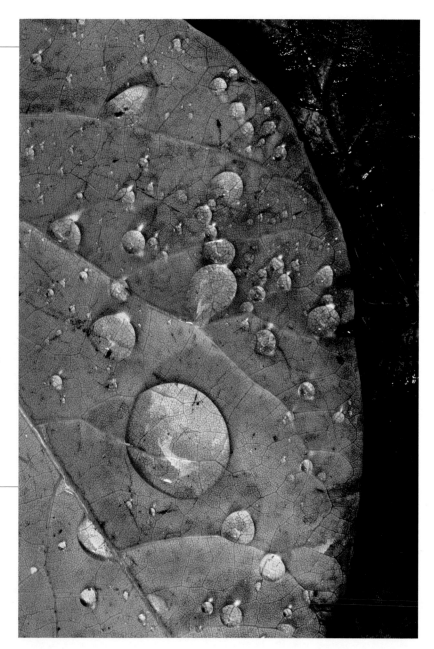

18 Use a tripod

If there is one single thing that distinguishes most professional photographers from most amateurs, it is that the former always use a tripod if they can, and the latter seldom do. It can make a huge difference to your pictures, and many of those who never use a tripod have little idea how sharp their lenses really are. Using a tripod eliminates the risk of camera shake, and while it's possible to 'get away with' hand-holding a camera when shooting on a bright day, it's worth bearing in mind that even a fast shutter speed, such as 1/250 sec, will not necessarily prevent a small degree of blur taking the edge off an image. A tripod will also allow you to use small apertures for greater depth of field, as well as making it easier to frame and compose your images more carefully. A tripod enables you to shoot pictures at times and in places where light levels are low, but when potential subjects are often most interesting and effective.

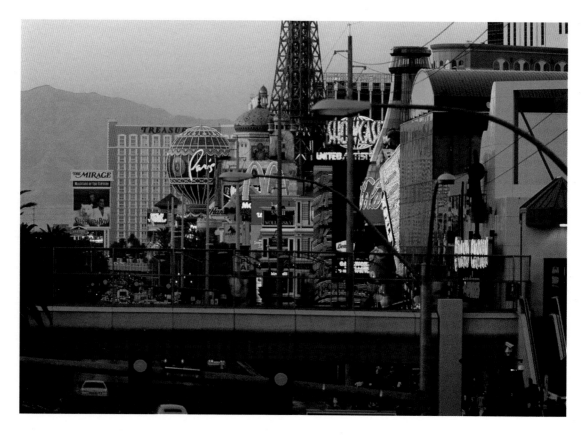

Las Vegas

first view The first sight of Las Vegas can be something of a shock for the unprepared, as it is a brash, discordant array of signs, colours and outrageous architecture that can be difficult to photograph in an ordered and well composed way.

in camera Having taken some shots in daylight I decided to see if dusk would create a softer, more atmospheric quality. I took this shot shortly before sunset from a footbridge spanning the main street. I used a long-focus lens set to a small aperture for good depth of field and, with the camera set on a tripod, used a shutter speed of 1/2 sec.

35mm SLR camera; 70–200mm zoom lens; Fuji Velvia

19 Use a long-focus lens to isolate details

A change of lens can have a strong influence on the way we see things in a photograph. In normal circumstances, we tend to see the world in a similar way to the view through a standard lens, with a field of view of about 45 per cent. Fitting a wide-angle or long-focus lens on the camera can present potential subjects to us in quite different ways. There are many circumstances when the wider view of a scene or subject may not be very interesting or photogenic, but there may be details in the general view that can be isolated and enlarged using a long-focus lens to create striking images. The act of isolating an object or detail from its setting can present it in a way that makes it seem less familiar, so that we learn to look at it in a fresh way. It can also create an abstract quality, and may introduce an element of ambiguity that will create an eye-catching picture.

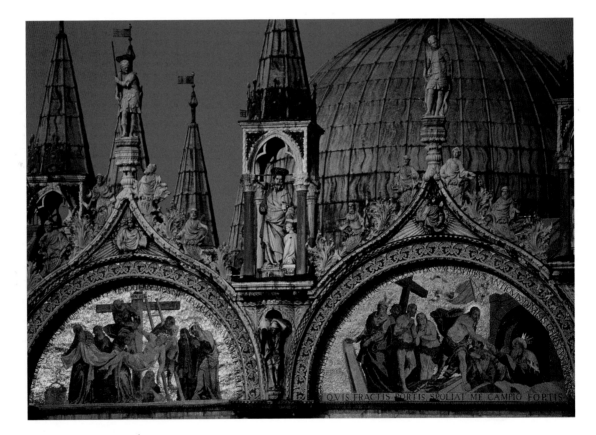

Doge's palace

first view The first sight of the Doge's Palace in St Mark's Square in Venice is pretty breathtaking, and many millions of photographs must have been taken of it. But like many such imposing buildings, there is almost too much to take in when it is viewed in its entirety. I was lucky on this occasion that the sun was in an ideal position to light the details on the building's façade very effectively, and I decided to look at them in closer detail.

in camera I fitted my 70–200mm zoom lens and began exploring the possibilities of isolating just a small area of the decoration. I found several that worked well, with slight changes in the viewpoint. I liked this best because of the glowing quality of the gold relief. I used a tripod combined with mirror lock and delayed release to ensure there was no vibration to spoil the sharpness of the image.

35mm SLR camera; 70–200mm zoom lens; Fuji Velvia

20 Use a fill-in flash

Most cameras today have a small built-in flash gun, powerful enough to shoot pictures indoors when available light exposures are not possible, but which can also be used to supplement existing lighting that otherwise creates deep shadows and too much contrast, such as in outdoor portraits. You must ensure that the subject is within the indicated range and that the shutter speed is not too fast to synchronize with the flash: this will differ according to the camera in use, and will be shown in the instruction manual. The same technique can be used for shooting in low light when the background is illuminated, such as at sunset. The principle is easier to understand if you consider it as two separate but simultaneous exposures. The light from the flash is balanced to give the correct exposure at a given aperture and the shutter speed allows the areas lit by the ambient light to be exposed correctly.

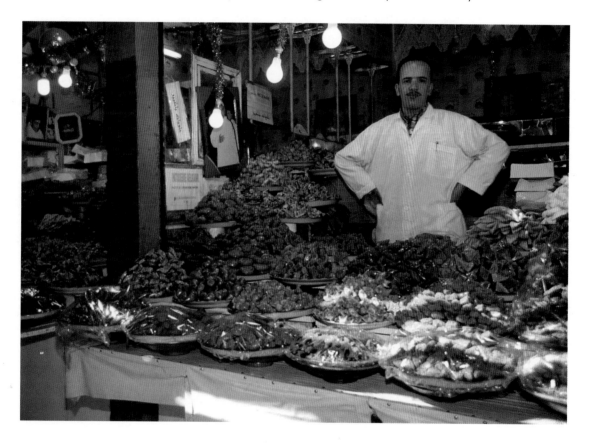

Candyman

first view The souk in Marrakech is a wonderful place to explore, containing a maze of alleys and passages in which almost everything you might think of can be bought. It's mainly undercover but in places some daylight filters through and the stalls are lit by tungsten lights. This man was selling delicious candies made from ingredients like honey, almonds, dates and figs, all wrapped in filo pastry. He readily agreed to let me take a photograph.

in camera There was just about enough light to shoot hand-held using a fast film, but the tungsten lighting left some deep shadows and the foreground in particular lacked detail. With my exposure set to record the ambient light, I used flash to illuminate the shadow areas and to give more definition to the candies close to the camera.

35mm SLR camera; 24–85mm zoom lens;
Fuji Provia 400F

31

Composition

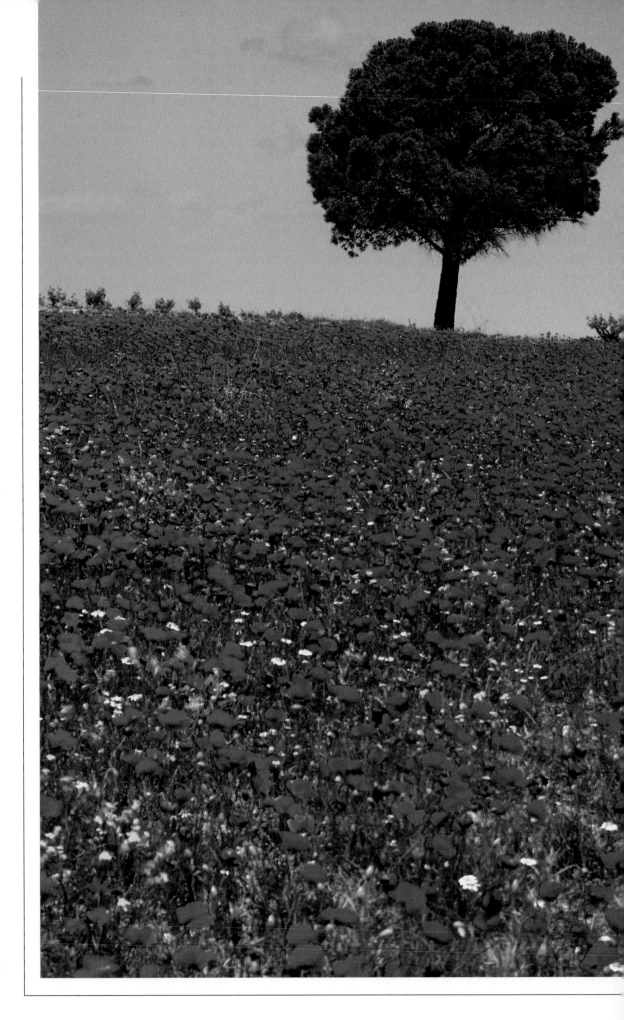

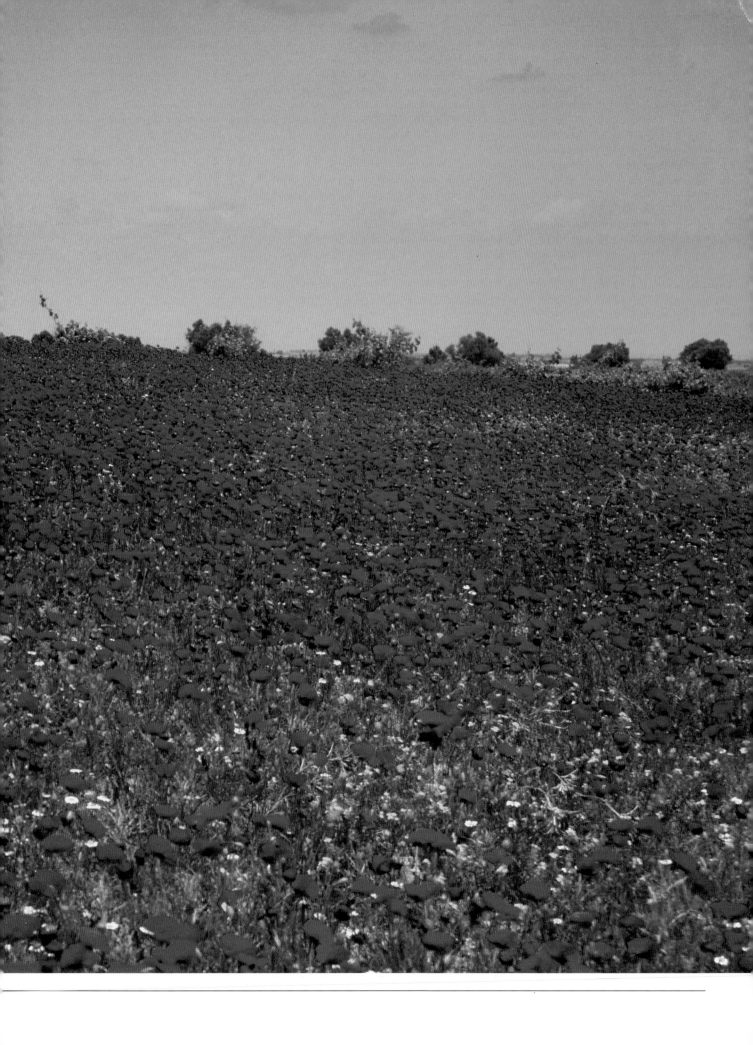

21 Be selective

Deciding what to leave out of a photograph can be as important as what to include. A large proportion of disappointing photographs are the result of including too many conflicting elements. Less is often more in photography, and greater impact can be achieved by taking two or more photographs of a scene, instead of trying to include everything in a single image. It's important to recognize the essential elements in order to select the right viewpoint and the best way to frame the image. A good photograph depends as much upon abstract visual elements such as pattern, texture, shape, form and colour as it does on the subject itself, and identifying them should be the first step in the process of selection.

Two gondolas

first view It would be very hard to visit Venice and not take a photograph of gondolas as they are so characterful, with their elegant shapes and beautiful decoration. But it is so easy to finish up with a hackneyed image, and I wanted to produce something that was more original and striking.

in camera These two were moored by the canalside and the bold red paint and patterned carpet caught my eye. I decided to make these features the focus of attention and chose a viewpoint that allowed me to look almost directly down on the boats.
I angled the camera so the hulls created a diagonal line, and framed the photograph in a way that placed the two areas of colour in opposing segments of the image.

35mm SLR camera; 24–85mm zoom lens; Fuji Velvia

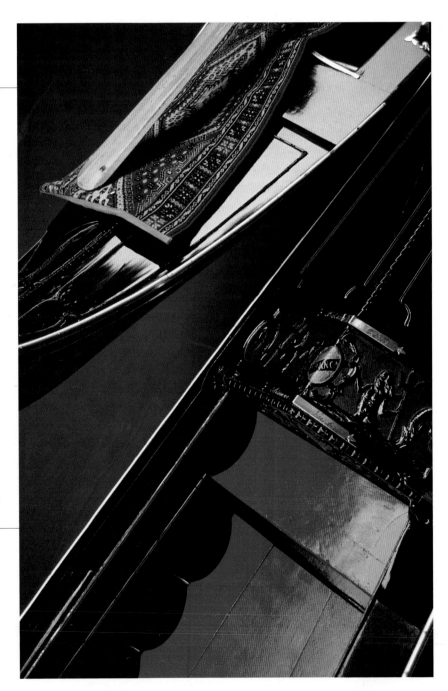

22 Move close to your subject

Most photographers find that their pictures frequently include more of a scene than they had expected. One reason for this is that many cameras have a fairly large built-in safety margin, with the viewfinder showing significantly less than will appear on the film. Another reason is that it's very easy to concentrate on the subject so much that you become less aware of the area surrounding it: in effect, you magnify it mentally. Filling the frame with the subject, and ruthlessly excluding less important details, is a sure way of creating an image with impact. A great many pictures that seem a little flat and uninteresting could have been stronger and more eye-catching had the photographer simply moved closer to the subject.

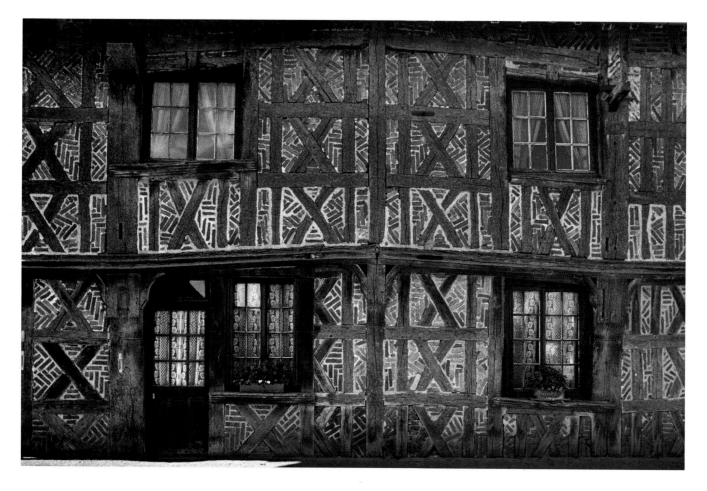

Sologne house

first view The Sologne region of France is notable for its distinctive architecture and fine old timber-framed houses. This colourful example was in a small village street and I first looked for a viewpoint that would allow me to include more of the scene.

in camera On looking more closely, I realized that the essence of the image I wanted was the façade itself, with its intricate pattern of bricks and timbers. Including the roof, the street in the foreground and the adjoining houses would only have detracted from it. I took up a much closer viewpoint that excluded all the other elements, and filled the frame with the pattern.

35mm SLR camera; 35–70mm zoom lens with 81A warm-up filter; Fuji Velvia

23 Frame it as an upright

I would not be surprised to find that less than five per cent of photographs are taken using the vertical orientation. This has little to do with composition; the main reason is that most cameras are much easier to hold in the horizontal position and, even when using a tripod, supporting a camera in the upright position is more awkward. But a very large proportion of photographs would be much more pleasingly composed if they were shot as uprights. Like all habits, holding a camera horizontally is a hard one to break. My solution is always – well, nearly always – to consider the upright option first. If you do this you can explore the possibilities of composing within this shape before considering the scene as a horizontal image. If you do eventually shoot it as a landscape shape, it will be with the knowledge that that was the best solution.

Horse pots

first view This extraordinary display of pottery horses was assembled at a shrine in a small village in Gujarat, India. They are offerings made by families giving thanks for the birth of a child. I was anxious to show the huge number of pots, as well as the tree that shaded the small shrine.

in camera I found a view-point that looked across the widest expanse of pots, and showed them forming a V shape, which I felt would add impact. I got close to the pots and as high as possible. Using a wide-angle lens, the upright format enabled me to include all of the foreground pots as well as the top of the tree.

35mm SLR camera; 17–35mm zoom lens with polarizing and 81A warm-up filters; Fuji Velvia

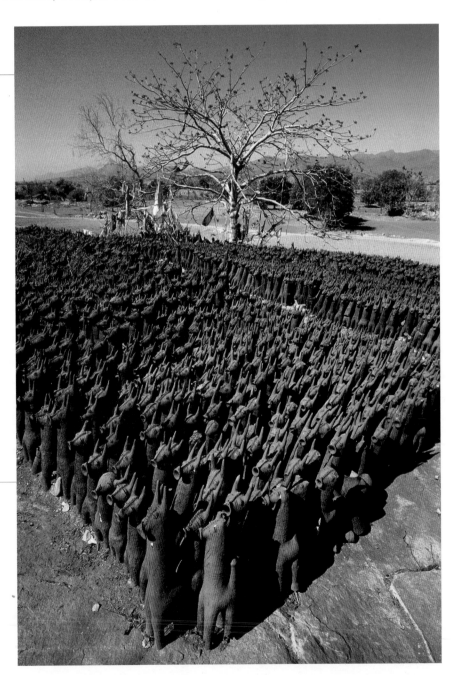

24 Exploit the panoramic format

Many cameras now offer the option of framing a scene in the panoramic format, and there are also a number of dedicated panoramic cameras on the market, such as the Hasselblad XPan. This shape has some distinct advantages, as there are many occasions when the normal 2 x 3 format includes areas that are uninteresting or distracting. When you are shooting wide-angle landscapes, for example, there is sometimes too much uninteresting foreground or sky, which will dilute the impact when a normal picture shape is used. With a panoramic shot you do need to ensure the horizon is level, as the narrow shape will emphasize any deviation: a small spirit level on the camera can be useful in this respect. Although most panoramic shots are made using the horizontal orientation, don't overlook the possibilities of the upright format.

Lee Bay

first view The early morning light can be beautiful on this beach in north Devon and, when the tide is out, the smooth, rock-strewn sand provides some good picture opportunities.

in camera This particular rock caught my eye, partly because of the way it was lit but also because, from this viewpoint, it seemed to lead the eye away towards the distant headland, creating a pleasing sense of perspective. Using a wide-angle lens from quite close up allowed me to frame the image in the way I wanted, and I chose the panoramic format in order to exclude unwanted details on each side of the main area of interest.

35mm Panoramic camera; 45mm lens with polarizing and 81A warm-up filters; Fuji Velvia

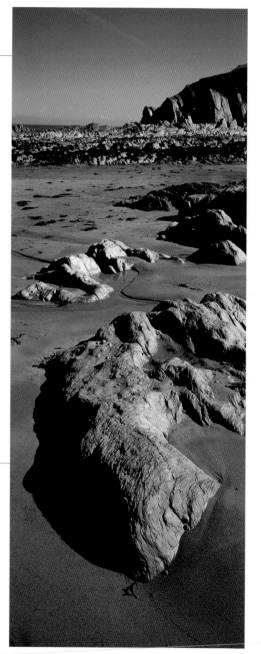

25 Identify a focus of interest

Good composition depends on a number of factors, such as the choice of viewpoint and the framing, but before decisions can be made about these it is necessary to identify a focus of interest. This may be quite obvious, such as a lone tree on a hill, but could be something much more subtle, such as a highlight, a shadow, a splash of colour or the shape of a cloud. Once you have established this, it is easier to decide on the best viewpoint, and where to place the object within the frame. The 'Golden Rule' of composition states that it should be placed at the intersection of thirds – where lines dividing the image into three laterally and vertically would meet – but this is, at best, only a guide and ultimately its position should be determined by the way the other elements of the image are distributed around it to create a good balance.

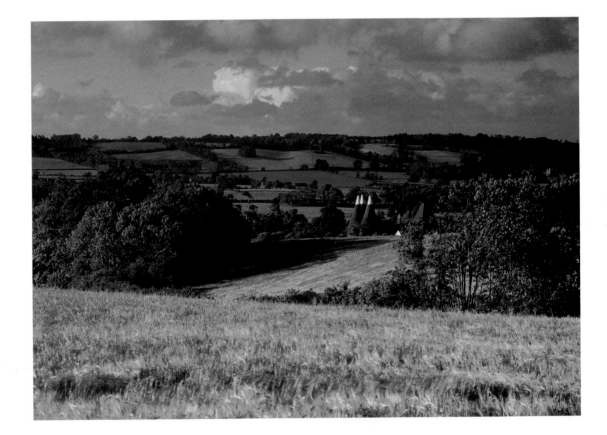

North Downs

first view This part of the North Downs in Kent is quite near my home and I pass the spot quite regularly, but I had never before been tempted to photograph this view. On this occasion, the combination of the colour of the landscape, the cloud formation and the light seemed just right. In particular, the light seemed to make the oast houses much more prominent than they usually appear.

in camera Because the buildings had become such a distinct focus of interest, it became much easier to choose a viewpoint and frame the image so that all of the other details created a nicely balanced composition. I used a long-focus lens to isolate the most interesting area of the scene, and to exclude unwanted details.

Medium format SLR camera; 105–210mm zoom lens with 81B warm-up and polarizing filters; Fuji Velvia

26 Create balance and harmony

If a picture is to be satisfying and easy on the eye, it needs to be composed in a way that creates a pleasing balance, with all the main elements of the image contributing to the whole and supporting one another, rather than each vying for attention. One way to achieve this is to imagine the focus of interest in the picture as being one point from which a print of the image might be suspended. As you consider how to include the other main elements of the scene, visualize them as the other points of suspension, and decide where these would need to be to make the print hang fairly level. It can help to half-close your eyes, so that the main features of the image are seen more readily. As well as objects and details, areas of shadow, highlight and colour also need to be considered in this way.

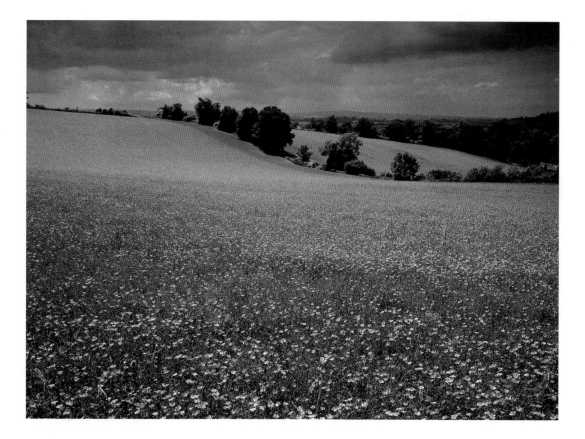

Field of flax

first view I photographed this view of a valley near my home on a day that was quite cloudy, so that the light was very soft. But there were gaps in the cloud that gave the sky some interest and also created some contrast. The scene was further enhanced by the light tones of the flax blooms set among the darker green foliage.

in camera I found a viewpoint that placed a dense area of flax near the camera and gave a view of the hedgerow and trees which, with the small bright area of sky, became the focus of attention. I framed the image, imagining the area of the field around the hedgerow to be the point around which the image was balanced, but with the main weight of interest biased a little towards the foreground. I used a small aperture to make sure the image was sharp from front to back.

Medium format SLR camera; 55–110mm zoom lens with neutral-graduated filter; Fuji Velvia

27 Use a natural frame

Photographic prints often gain impact when they are given a border, such as a bevel-cut overlay or an arty, ragged, black edge. It's also possible to create this effect within the image itself, by making use of 'framing' objects in the foreground. This can work especially well with subjects such as landscapes and architecture, where the accentuated perspective enhances the impression of a third dimension. In this context, the 'border' does not necessarily need to surround the scene completely. The overhanging branches of a tree, for instance, can work very well in this way, while also helping to break up or mask an uninteresting sky. If the foreground detail is to be in sharp focus you will need a small aperture to ensure adequate depth of field, but the border effect can also work well on occasions when it is blurred.

Gerberoy

first view Gerberoy is a very pretty small village in Picardy in northern France, noted for its annual rose festival. It has many old timbered cottages and cobbled streets. I wanted to find a viewpoint that would convey something of the village's atmosphere, rather than just making a straightforward architectural record, and spent a while exploring the possibilities.

in camera On one side of this small street there was a covered market hall, and I went inside to see if I could use one of the arches as foreground interest. This one gave me a good view of the house opposite. I chose a viewpoint that allowed me to include all of the arch in the foreground and the most interesting area of the house and street beyond. I used a small aperture to ensure there was enough depth of field to record both in sharp focus.

Medium format SLR camera; 55–110mm zoom lens; Fuji Velvia

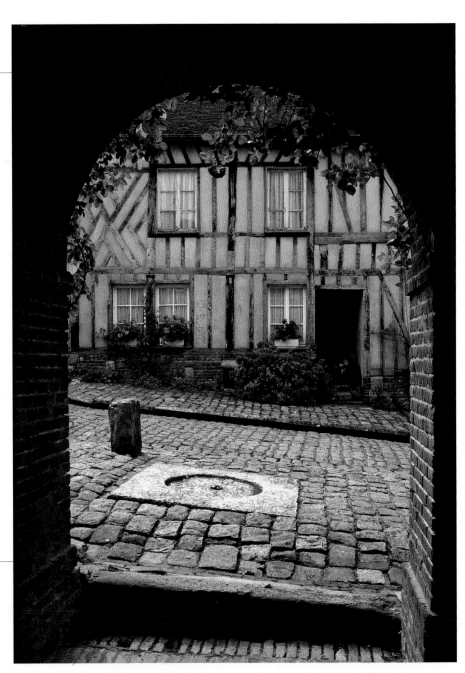

28 Try a low angle

The vast majority of photographs are taken at eye level from a standing position, usually because the photographer happens to be standing up when the subject presents itself. Changing to a lower viewpoint can be surprisingly effective in giving an image a stronger and more unusual look. Even getting down to a kneeling position, for instance, can make a big difference. A full-length portrait is a good example of a picture that can be improved by this means. Photographing a person from an eye-level viewpoint can create a foreshortened perspective, making the subject's head and shoulders look disproportionately larger than the lower body. If you can get the camera lower, looking up at a subject can often give a picture a particularly dramatic and dynamic quality, especially when a wide-angle lens is used.

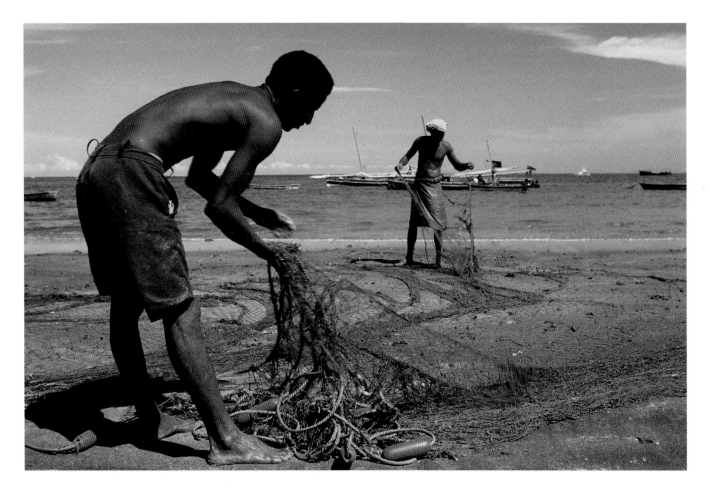

Kenyan fishermen

first view I chanced upon this beach scene while driving north along the Kenyan coast from Mombasa, and spent a while watching the fishermen coiling their nets. I wanted to photograph them but could not find a viewpoint that produced a nicely balanced composition. One problem was that they did not stand out clearly enough from the background.

in camera As soon as I decided to take a look from a much lower angle the composition changed for the better. Using a wide-angle lens from quite close emphasized the perspective, and the horizon became lower in relation to the men, leaving their upper bodies more clearly defined against the sky.

35mm SLR camera; 28–70mm zoom lens; Fuji Provia 100F

41

29 Use a bird's eye view

Just as a low viewpoint can help to create eye-catching pictures, so can an unusually high one. Even something as simple as standing on a wall, or a chair, can make a big difference to the composition and look of a photograph when the subject is close to the camera, especially when a wide-angle lens is used. Some landscape photographers carry a stepladder to raise their camera, to make the most of foreground details, and a friend of mine fits a wooden platform on his vehicle's roof rack. High viewpoints obviously include tall buildings, from which you can shoot spectacular views. If you are shooting from a viewing gallery through a window, try to choose the cleanest area of glass and place the lens as close as possible to it.

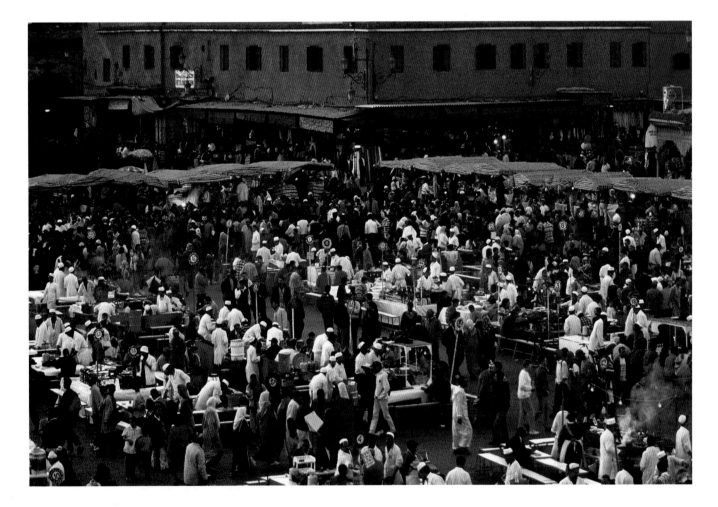

Djema el Fna

first view The main square in Marrakech is one of the most exciting and colourful places I've visited. During the day it teems with snake charmers, story tellers, acrobats, dancers and musicians, but as the sun goes down, the entertainers leave and are replaced by dozens of small food stalls, where all manner of Moroccan delicacies are prepared on small charcoal and oil burners.

in camera Although it's great to mingle with the crowds, for a photograph it's hard to beat looking down on it all from one of the roof terraces of the cafés that border the square. I used a long-focus lens to isolate the most interesting area of the scene, and had the camera supported on a tripod.

35mm SLR camera; 70–200mm zoom lens;
Kodak Ektachrome 100SW

30 Explore the viewpoints

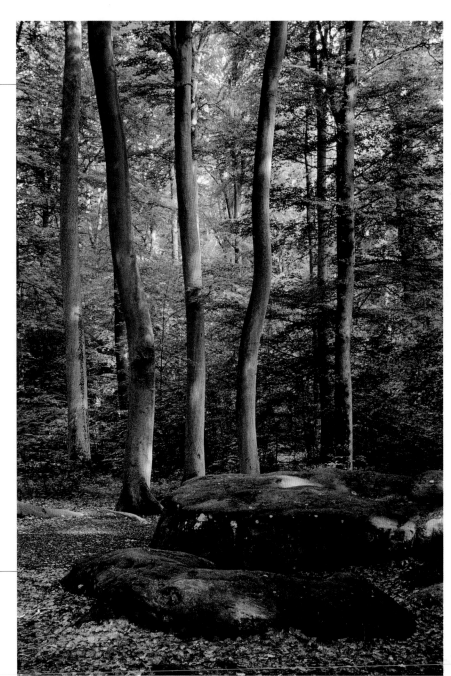

I once watched a group of tourists descend from a coach that had stopped at a well-known site. They all shot their pictures without moving more than a few paces from its door. Finding the best viewpoint is one of the main keys to success in photography, and exploring all the possibilities before you begin to shoot should become second nature. Often a shift in position of just a couple of steps can make a significant difference, because it alters the relationship between objects that are at varying distances from the camera. Moving to the left makes closer objects move to the right of more distant ones, and vice versa, while moving closer makes near objects appear larger than more distant ones, and moving further back makes them appear smaller.

Forest of Compiègne

first view I am fascinated by trees and forest scenes, and the Forest of Compiègne in northern France is one of my favourite locations. On this visit in early summer, the fresh green of the foliage was enhanced by the hazy sunlight filtering through the trees. But this made it a quite 'busy' scene and I needed to find a way to make the image hang together.

in camera I felt this small cluster of boulders would provide an effective foreground and act as a focus of attention. I chose a viewpoint that placed it in the best position in relation to the more distant trees. I then found it necessary to move the camera just a little to each side until I found a spot where the tree trunks were displayed in the most balanced way, with a similar gap between each and without too much overlapping.

35mm SLR camera; 28–70mm zoom lens with polarizing and 81A warm-up filters; Fuji Velvia

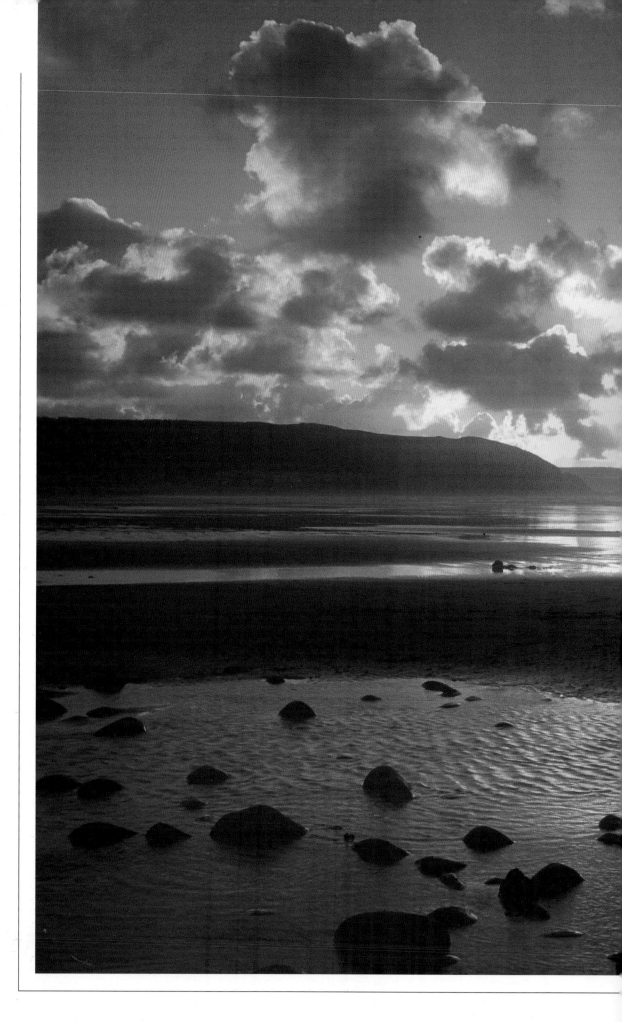

Working with light

31 Judge the contrast

That film can record colour, tone and detail so well is a small miracle, and early photographers would be astonished at the quality of today's images. But film can only record a limited brightness range satisfactorily: if the difference between the highlights and shadows is greater than this the result will be dense shadows and burnt-out highlights, resulting in a harsh and unattractive image. Conversely, if the brightness range is too small, the results will be flat and muddy. A key to producing good quality pictures is learning to avoid subjects that are lit in such a way that they will not record well. Viewing a potential subject through half-closed eyes can help you to judge the true depth of the shadows and brightness of the highlights.

Denver tower blocks

first view The sky was crystal clear when I left my hotel in the early morning, and the low-angled sunlight was glancing off the angular façades of these buildings in a way that created a very wide brightness range. In normal circumstances this would have resulted in an image that was simply too contrasty, but it made the reflections even more striking.

in camera I decided to try to make use of the contrast to produce a dramatic effect, and looked for a viewpoint from where the reflections would appear in the very dark areas the lighting had created. I gave an exposure that allowed the buildings to become almost black, with the knowledge that their outline would look striking against the light-toned sky. I used a polarizing filter to control the relative brightness of the reflections and shadows.

35mm SLR camera; 24–85mm zoom lens with polarizing filter; Fuji Velvia

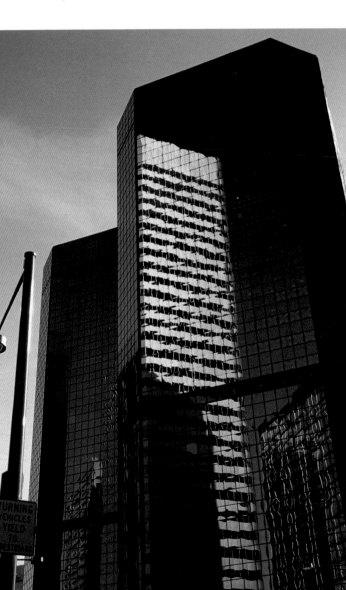

32 Look at the shadows

It's essential to develop an awareness of the quality and direction of the light, as well as the contrast in a scene. This is most readily seen by looking at the shadows. Notice how big and how dark they are, and whether they have hard or soft edges. With portraits and still lifes, the lighting can be changed by changing the position of the subject and, in the studio, the position of the lights. But with most outdoor subjects the viewpoint and time of day you choose to shoot are the only variables you can control. Avoid situations where the shadows occupy more than about a quarter of the image, unless they are weak and soft-edged. An image that is mainly in shadow is better than one that is half and half, especially if the shadows are dense and hard-edged.

Château Monbazillac

first view This viewpoint presents the most pleasing aspect of this lovely old building in the Dordogne region of France, but the photograph needs to be taken quite early in the day, when the sun is at a low angle. As it rises and moves towards the west the shadows become very large and, on a clear day, very dense, resulting in an image with a harsh, contrasty quality.

in camera I took this photograph at a point when I felt the sun had moved high enough to create well defined details and good texture on the ancient stone, but before the shadows became too intrusive: a window of opportunity of no more than an hour. I chose a viewpoint that allowed me to use a long-focus lens, which has compressed the perspective and made the vines seem much closer to the château than they actually are.

35mm SLR camera; 70–200mm zoom lens with polarizing and 81A warm-up filters; Fuji Velvia

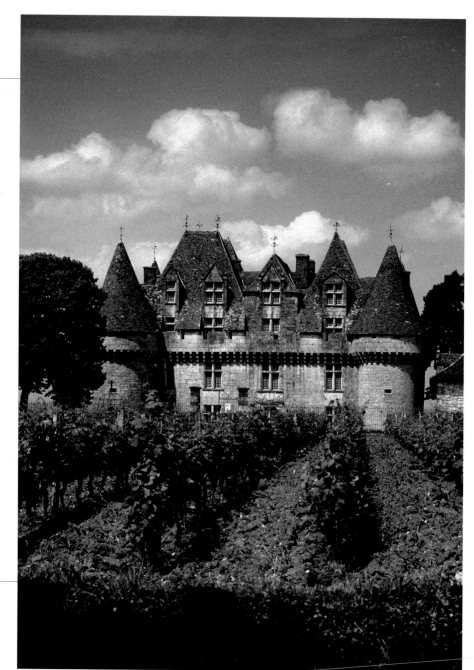

33 Shoot into the sun

One way of overcoming the problems of dark, hard-edged shadows on sunny days is to shoot into the sun, which can create eye-catching and atmospheric pictures. It usually creates a halo of bright highlights, which will cause the camera's metering system to indicate less exposure than is needed, resulting in an underexposed image. Many cameras have a 'backlight button' that increases the exposure by a set amount, but more or less than this is often preferable. It's best to take a close-up or spot reading from a mid-tone within the subject. You should also ensure that direct sunlight does not fall onto the lens as this will cause flare. A lens hood will not always prevent this and it is best to shield the lens with your hand or a piece of black card.

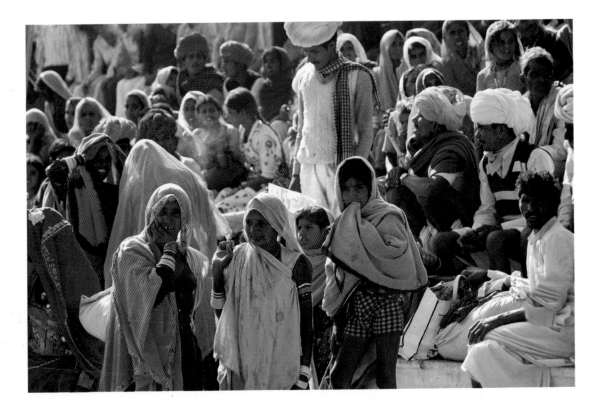

Pushkar gathering

first view I travelled to Pushkar, a small town in India, to photograph a spectacular event – the annual camel fair. A vast tented village is set up on the dunes surrounding the town where many thousands of camels, people and other assorted animals gather from all over the surrounding area. The climax of the three-week event is the camel races held in a big arena where the very colourfully dressed spectators make a stirring sight, in many ways just a photogenic as the action they are watching.

in camera By now the sun was quite high in the sky and very harsh, creating deep, dark shadows and brilliant highlights. The only way of producing an image where the contrast would be acceptable, and the colour and detail not lost, was to find a viewpoint that allowed me to shoot directly into the sun. It was necessary to shield the lens with my hand to prevent flare – I don't use lens hoods, as they are seldom effective in these circumstances. I took a meter reading from a mid-tone in the scene, being careful to avoid the brightest areas. This indicated just over a stop more than the normal averaging reading.

35mm SLR camera; 70–200mm zoom lens; Kodak Ektachrome 100SW

34 Shoot on dull days

Most photographers feel the urge to go out and take pictures on bright, sunny days when the sky is blue. However, while these conditions can be ideal for many subjects, there are others when the softer light of an overcast day can be much more effective. A complex subject that includes a lot of busy details can easily become an incomprehensible muddle when there are dense, hard-edged shadows and bright highlights to add further confusion to the image. Delicate colours may also be overwhelmed by harsh direct sunlight. A colourful market scene is a good example of a situation in which the soft light of an overcast day can create a more pleasing and effective illumination.

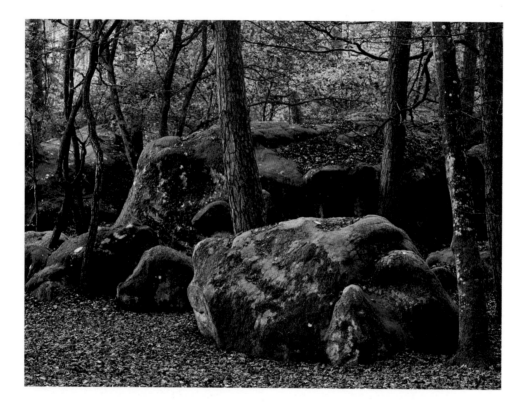

Forest of Fontainebleau

first view This beautiful French forest to the south of Paris is a favourite spot of mine, and is at its best in the autumn. On this occasion, very late in the year, the trees had lost most of their leaves. The sky was heavily overcast and it was beginning to get dark. But the light quality was very pleasing and made possible shots that would not have been successful on a sunny day.

in camera This viewpoint allowed me to include a very attractive cluster of moss-covered boulders which, in sunlight, would have lost much of their colour and detail. I composed the image so that they occupied most of the frame, and areas of the sky visible between the trees were excluded. I used polarizing and warm-up filters to maximize the colour saturation and to emphasize the red leaves. Using a tripod permitted a slow shutter speed, about 1 sec, so that I could use a small aperture for good depth of field.

Medium format SLR camera; 55–110mm zoom lens with polarizing and 81A warm-up filters; Fuji Velvia

49

35 Shoot in golden light

You can never guarantee success when you go out to take photographs, but good results are almost certain if you get up early or stay out late. On a clear day, when the sun is close to the horizon, the light has a magical quality which, with the right subject, can produce pictures that stand out from the rest. The warm, mellow light greatly enhances subjects such as landscapes and buildings, and the low angle casts long shadows, producing atmospheric photographs with a rich textural quality and a full tonal range. However, the choice of viewpoint becomes more restricted with acutely angled lighting, and it's usually necessary to choose either morning or evening light to suit a particular subject.

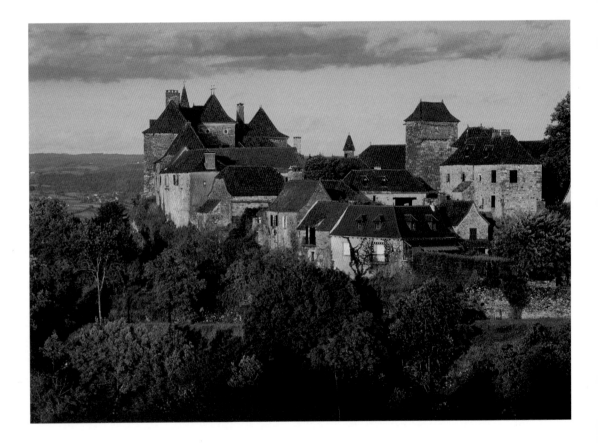

Loubressac

first view This very attractive village in the Dordogne region of France is set on a hill overlooking the valley. The small road that leads up to it provides a very good viewpoint, which I had used before. On this occasion the sky had been clear nearly all day, and I guessed that there would be a good chance of an unobscured sun illuminating the village just before it set, to give that lovely rosy glow that only exists for the last fifteen minutes or so before sunset.

in camera I arrived at my chosen spot in plenty of time to decide on the exact viewpoint, angle and framing, and then sat back to wait for the sun to go down as far as it could before shooting. As I waited, a few small clouds bubbled up, but fortunately they did not mask the sun until about five minutes before sunset, so I was able to take my shots, if a little earlier than planned.

Medium format SLR camera; 105–210mm zoom lens; Fuji Velvia

36 Photograph illuminated buildings

When a building is illuminated it offers an opportunity to take a photograph that is very different from the norm. The success of the outcome will depend upon a number of factors, but how well the building is lit is the first to consider. If the lighting is very uneven, there are likely to be areas that are very bright and others that are in deep shadow. To some extent this can be overcome by making sure that you exclude the extremes through your choice of viewpoint and the way in which the image is framed. It will also help a great deal – and will improve the overall quality of the image – to shoot early in the evening, while there is still a little daylight and before the sky becomes completely black.

Château Pichon Longueville

first view I had been commissioned to shoot the pictures for a book about the French wine village of Pauillac, where some of the world's best red wines are made. Of all the châteaux in the region this one is undoubtedly the most photogenic, and was a front runner for the book's cover image. I had intended to photograph it at sunrise, as it faced due east, but on several occasions when I tried to do so, a cloud bank obscured the sun for the first hour or so, by which time it had lost its rosy glow.

in camera On this occasion I arrived very early, long before dawn, to find the château still illuminated, though normally the lights were switched off around midnight. I chose a full frontal viewpoint and framed the image so that the illuminated areas filled the viewfinder. It was still very dark, and I waited for nearly half an hour until I felt there was enough light in the sky to show the building's outline clearly.

Medium format SLR camera; 50mm shift lens; Fuji Velvia

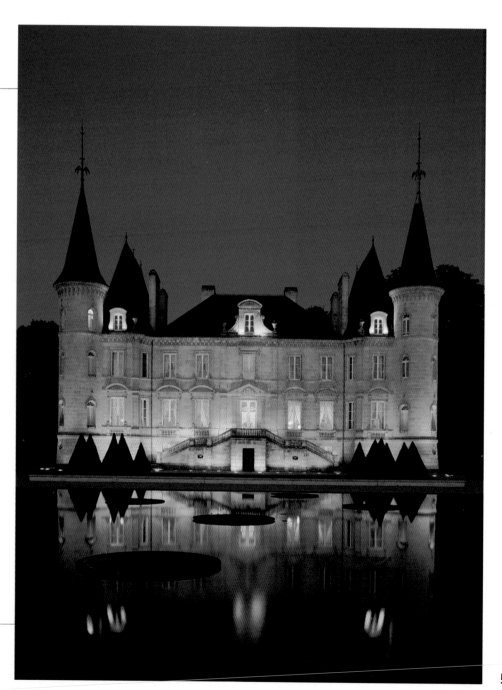

37 Shoot at dusk and dawn

The quality of light that occurs just after the sun has dipped below the horizon, or before it has risen, can create some very interesting and atmospheric effects, even when the sky is obscured by cloud. Dusk and dawn light has a colour quality that is both unique and somewhat unpredictable. It is usually quite soft, producing muted colours and low contrast. For this reason it works best with subjects that include bold shapes in the foreground, which add darker tones to the image, or where there are bright reflective objects or details, such as water. Exposure will inevitably be longer than in normal daylight, and several seconds or more may be needed; for this reason it's essential to use a tripod.

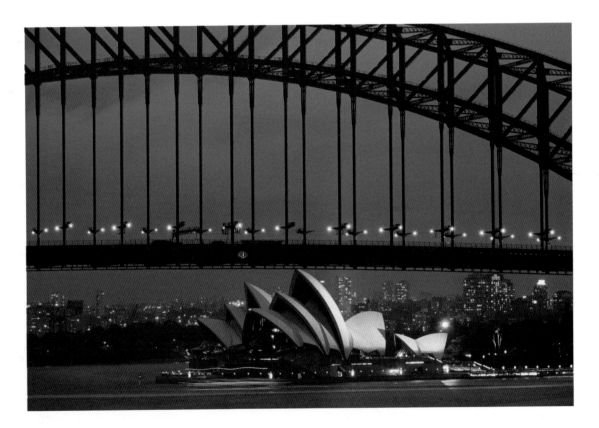

Sydney Harbour

first view A friend had recommended a hotel when he heard I was going to Sydney, saying that it had a good view. You can imagine my delight, on going to my room, to see this scene from the window. It meant that I was able to shoot pictures at various times of the day with great ease. I managed to take some good shots at sunset, sunrise and with the buildings illuminated, but I hoped also to find a way of shooting a less postcardy image.

in camera This day had been cloudy and wet, and it became quite dark before many of the lights in the city had been switched on, producing this bluish, atmospheric quality and giving me the opportunity to take the unusual shot I'd hoped for. I needed a tripod as the exposure required was about 1 sec, and I used a long-focus lens to frame the most interesting area of the scene.

35mm SLR camera; 70–200mm zoom lens; Fuji Velvia

38 Use available light

When the light is low, many people reach for their flash guns, but this is not always the best option. A flash gun used in the normal way replaces the ambient light, and in doing so, completely alters the character of a place. This can be disappointing when shooting pictures where the lighting is an integral part of the atmosphere. There are many very fast films available now that will allow you to use reasonably fast shutter speeds in ordinary tungsten lighting. Choose viewpoints that exclude the deepest shadows, and try to frame the shots in such a way that no one part of the scene is lit much more strongly than another. When taking exposure readings, avoid including light sources, as this will result in underexposure.

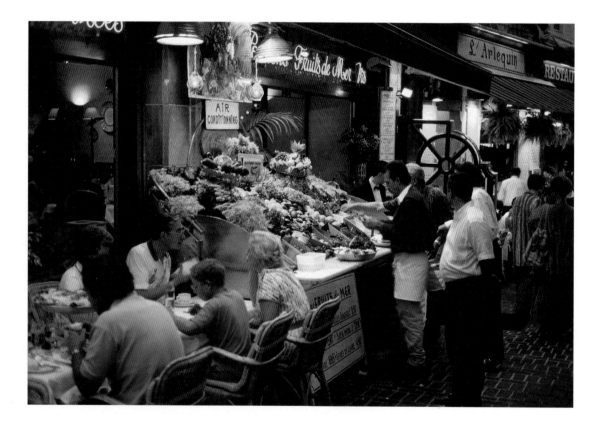

Brussels café

first view This charming small cobbled street in Brussels is lined with cafés and restaurants. Although it looks very attractive in daylight, it really comes into its own after the sun has gone down, when the glowing lights create an inviting and intimate atmosphere.

in camera I wandered along the street looking for an attractive, well lit corner that was not too crowded and did not have any dense shadows. This restaurant, with its magnificent display of seafood, seemed ideal. I chose a viewpoint that gave an angled view of the illuminated façades, and framed the shot so that there were no excessively bright or dark areas. There was just a little weak daylight remaining, and I opted to use daylight transparency film so the tungsten lights would create a reddish tint.

35mm Rangefinder camera; 45mm lens;
Fuji Provia 400F

39 Photograph interiors

Shots of a building's interior can often be more interesting and eye-catching than those taken outside. Churches are a good example: quite frequently, an austere and unphotogenic building hides a richly decorated and colourful interior. Small flash guns cannot be used for this, and the only practical solution is to make use of the ambient light. This may be daylight, artificial light, or a mixture. If the space is lit by artificial light alone, tungsten-balanced film will give the most neutral result, otherwise daylight film is best. The secret is to frame the image to avoid both large areas of dark shadow and bright highlights. In daylight, try not to include windows. A slow shutter speed may be needed, making a tripod invaluable, but if this is not allowed you can try using a faster film and bracing the camera against a firm support, such as a column.

Cordoba cathedral

first view The interior of Cordoba cathedral is, I think, much more interesting as a photographic subject than its exterior. The best-known image of the building is that of the forest of columns in the original Moorish construction, but after their defeat in the 13th century it became a Christian church and then a cathedral, and I was interested in photographing this aspect of the building.

in camera To some extent the choice of viewpoint, camera angle and framing has to be determined by the way the interior is lit, since flash would not be an option for such a large space. This area was especially well lit, mainly by daylight. There was an absence of deep shadows and it was possible to exclude the windows, creating a fairly evenly illuminated subject. I used a tripod to give an exposure of about 1/2 sec.

35mm SLR camera; 20–35mm zoom lens; Fuji Velvia

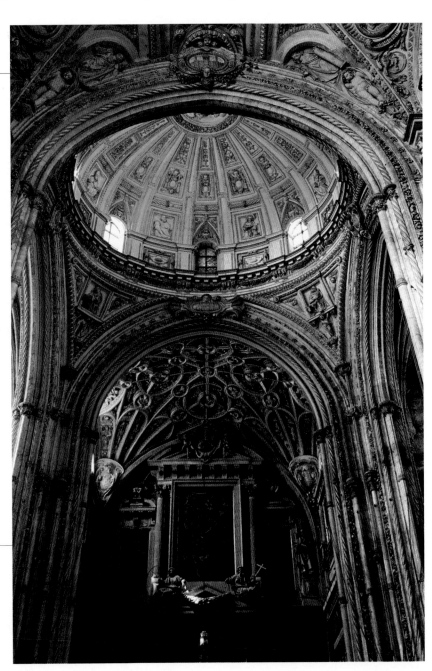

40 Photograph cities at night

City views are frequently more interesting to photograph after the sun has gone down because, when lit well, the resulting pictures will be more colourful and exciting. Distracting and unattractive details, such as parked cars, will be much less obvious than in broad daylight, and your pictures are likely to have more atmosphere and impact. The best time to shoot pictures like these is when the sky has become dark enough to make the lights glow quite brightly, but not so dark as to record as black on film. Exposure calculations need to be made carefully, as the inclusion of light sources within the scene will make it appear much brighter than it really is. It is best to take a reading from an area that excludes them. Because street lighting is usually from a mixture of different sources, it is best to use daylight film.

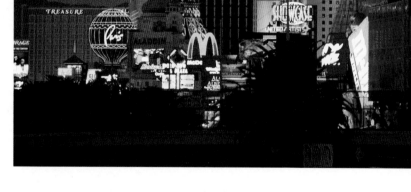

Vegas after dark

first view Finding a good viewpoint is one of the key factors in shooting cityscapes. In Las Vegas there is a walkway that crosses the main thoroughfare and provides some excellent views in various directions. I had discovered this earlier in the day, but I wanted to shoot some night pictures and waited until the sun had almost set before setting up my camera.

in camera Using a long-focus lens I framed the image to include the most interesting aspects of this view, but excluded areas that were not so well lit. At this time, although the sun had set, there was still too much ambient light for the illuminated areas to show up strongly enough, so I waited for nearly half an hour before judging that the balance between the lights and the sky was about right. I used the camera's mirror lock and delayed release to ensure there was no vibration during the 1/2 sec exposure that was needed.

35mm SLR camera; 70–200mm zoom lens; Fuji Velvia

Better colour

41 Avoid colour confusion

Taking photographs in colour is easy, you simply load up with the right film, shoot your pictures and take the film to a photo lab for processing. But taking good colour photographs needs a little more thought and care. It's important to appreciate just how powerful colour can be in an image; although most people will spend time carefully deciding between several slightly different shades when choosing clothes to wear, or paint to decorate a room, many give scant thought to colour when taking photographs. Too many different bold colours in a picture will invariably produce a muddled and unsatisfying image. It is important to ensure that the hues you are including in your picture do not fight with each other for attention, but contribute to a well balanced composition.

Two saris

first view Visiting a festival in India, I was surrounded by such a vivid blaze of colour that it almost hurt my eyes. Taking photographs of the event was not easy, as the huge range of bright colours created such a confusing and overwhelming sight that it seemed almost impossible for me to capture the vibrant atmosphere of the scene in a way that would not be equally confusing.

in camera On taking a closer look at my surroundings, I decided that all the colour and sense of excitement could probably be recorded successfully by photographing just a small area of the scene. I fitted a long-focus lens and began to study the crowd in more detail. I finally settled on these two women, who were sitting in the shade and were, consequently, quite softly lit. I cropped very tightly to exclude their faces as I felt this would have introduced a distracting and unnecessary element.

35mm SLR camera; 70–200mm zoom lens; Kodak Ektachrome 100SW

42 Look for a dominant colour

Although very colourful scenes are often the ones that inspire people to take photographs, they are actually the least likely to produce striking pictures unless considerable care is taken in the composition. If there are too many different colours in an image they will all compete for attention, especially when they are vivid and bright. One way of giving a colour photograph a bold, eye-catching quality is to select a subject in which one particular hue completely dominates the scene. This can be achieved by a careful choice of viewpoint, and the way in which the image is framed. The result can be even more telling if the other colours in the image are either quite subdued or create a contrast.

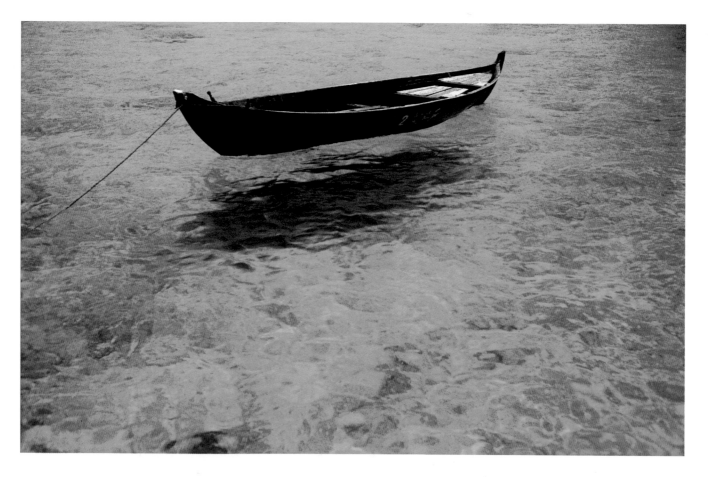

Maldive boat

first view The waters around the coral islands of the Maldives are protected by reefs, making them breathtakingly clear. The colours of the water range from pale turquoise to indigo. I wanted to find a way of capturing their beauty and translucency.

in camera This small boat moored in shallow water had cast a shadow on the sea bed and almost appeared to be suspended. I used a wide-angle lens from a close viewpoint, and framed the shot so that the water filled the frame and the boat appeared near the top of the image to balance the mass of blue. I used a polarizing filter to enhance the colour and translucent quality of the sea.

35mm SLR camera; 28–70mm zoom lens with polarizing filter; Fuji Velvia

43 Use colour contrast

One of the ways in which a bold, eye-catching picture can be almost guaranteed is to make use of contrasting colours. The most striking effect will be created when just two colours from well separated areas of the spectrum are included in the image, such as red against green or blue. A single red-sailed boat on a deep blue sea, for example, will have a powerful impact, even if the sail occupies only a small area of the image. The more saturated the colours are, the more eye-catching the result will be. The simplest combinations are the strongest: as soon as other colours are introduced into the picture the effect will be lessened, and if too many colours are included the result is likely to be an unsatisfying muddle.

Isle of Skye

first view I photographed this scene at the small port of Elgol on the Scottish island of Skye. The weather was appalling, with torrential rain and dark cloudy skies. I decided to take an exploratory drive to see if there were any possibilities, and when I arrived at this spot the rain had stopped and the cloud had thinned enough in places to create a little brightness.

in camera Although the distant mountains and stormy sky looked stunning, I realized that the image would need an element of contrast to give it impact. There were a few small fishing boats moored in the bay collecting lobster pots, and this bright red one was in an ideal position but some way off. I used a long-focus lens to frame the image tightly and make the boat as dominant as possible.

35mm SLR camera; 70–200mm zoom lens; Fuji Velvia

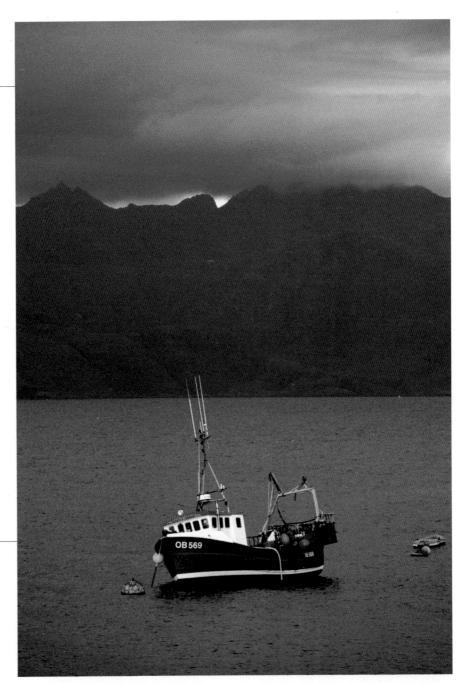

44 Photograph bright colours in soft light

On a sunny day everything tends to look more colourful than in overcast, dull conditions, but appearances can be deceptive, especially when boldly coloured objects are looked at quite close up. Bright sunlight creates both shadows and highlights, and both will make colour less saturated. The shadows add grey or black, and the highlights add white, making the colours less pure. For this reason, a very soft light that creates very weak shadows and highlights reveals the colours much more effectively. When shooting outdoors, an overcast day can provide the ideal lighting for bright, colourful subjects. If you are working with artificial light, the best results are obtained when the subject is illuminated by a diffused light source.

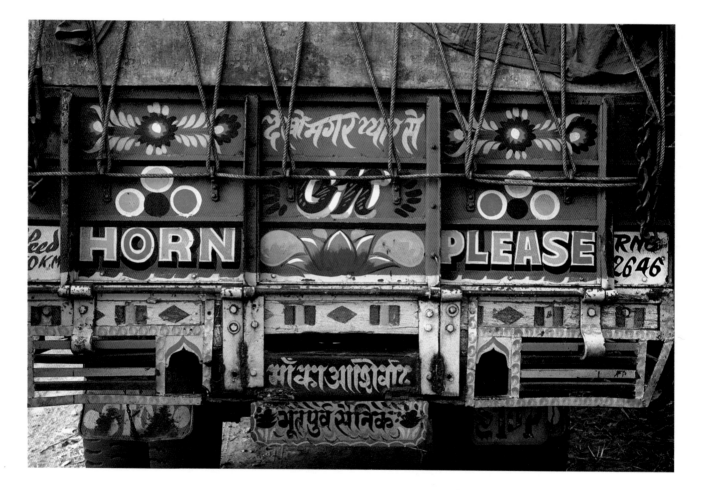

Horn please

first view While travelling by road in India I became fascinated by the decorated trucks we encountered. I was keen to photograph a good example and had been keeping my eye out for several days when I spotted this one. The request to sound a horn seemed pretty unnecessary, but I was told by my driver that you need three things in order to survive on Indian roads: good brakes, good horn and good luck.

in camera Apart from its sensitive use of colour and stylish typography (!), I liked this decoration because the truck was parked in the shade and its rear end was very softly lit, with virtually no shadows or highlights. This gave the colours an almost incandescent glow, and I needed only to frame the image tightly to emphasize them.

35mm SLR camera; 70–200mm zoom lens; Fuji Velvia

45 Expose for rich colour

Colourful subjects can make disappointing photographs if the exposure is not well judged. Only a small degree of overexposure will make hues appear much less saturated than they looked to the eye. Generally, it is best to slightly underexpose (by one third to half a stop) when using colour transparency film. With colour negative film, processed in an ordinary photo lab, the results can sometimes be disappointing because the prints are too light, and a much better result can often be obtained by asking for them to be made a little darker. The richest colour is recorded when the subject's brightness range is fairly low. Deep shadows and bright highlights reduce the colour saturation and prohibit the optimum exposure.

Pavement café

first view It was a wet, overcast day when I spotted this opportunity while wandering along a boulevard in Paris. I was attracted by the shape and texture of the chairs and the pattern they created, as well as their rich colour. The light was very soft and the scene had a low brightness range that made the colours appear even stronger.

in camera I chose a frontal viewpoint, quite close to the subject, and used a wide-angle lens to frame as wide an area of the subject as possible without including any unnecessary or distracting details. The scene was quite dark overall, and I decided to give significantly less exposure, about two thirds of a stop, than the meter indicated, as I wanted the red chairs to be recorded with maximum colour saturation.

35mm SLR camera; 17–35mm zoom lens; digital capture at ISO 400 setting

46 Create mood with colour

One of the most elusive qualities to capture on film is that of mood or atmosphere. With modern cameras and film, subjects are recorded with considerable clarity and detail, and this can easily diminish the sense of mood in an image. While the lighting and tonal range of a scene will have a considerable effect on this aspect of a photograph, colour is perhaps the most significant element. We respond emotionally to colour. Though it may sound clichéd, blues and greens really do evoke a peaceful and relaxed atmosphere, while orange and yellow create a cosy and inviting mood. Bright saturated colours suggest an upbeat and lively atmosphere, and dark muted colours produce a more sombre and introspective response.

Stripes

first view A local village fête provided this photo opportunity. Children were offered the chance to don a Velcro-studded suit and be stuck to a panel that was then spun around – well, they seemed to enjoy it. I was attracted by the brightly coloured stripes of the panel, which created a really lively and happy mood, and when this girl took up such a perfect position I couldn't resist a shot.

in camera From a frontal viewpoint I used a long-focus lens to frame the image tightly, excluding distracting details on each side. I waited for several spins until the girl produced a really animated expression and angled the camera a little so that her limbs formed diagonal lines before shooting.

35mm SLR camera; 70–200mm zoom lens; Kodak Ektachrome 100SW

47 Make colour the theme

An effective way to learn how to take good colour photographs is to regard colour as the key element of your images, and set yourself projects in which colour is the theme. You might take a series of photographs each illustrating a particular colour, trying to make each image as different as possible and introducing other visual elements like texture and pattern. As well as the more obvious interpretations, such as a leaf for the colour green, look for more unexpected ways of illustrating your chosen theme, such a park bench or a close-up of a painted fishing boat. It can help to visualize your pictures as a photo essay in which a number of images are seen together, perhaps as prints displayed on a wall.

Yellow

first view Building up a body of work is something with which many photographers are preoccupied. It usually means assembling a series of images of the same subject or location, but it can also be applied to wider themes. Over the years I've made themed collections of, among other things, colours.

in camera These images were taken over a long period of time, in different locations but each with the recognition that I was adding another image to a collection, in this case my Yellow archive. My aim is to take photographs that have a common thread but are also different in some way and have an individual identity.

48 Keep it simple

If there's a good general rule to follow in photography, it is to keep it simple, and this is especially true when working in colour. An image that includes only the essential elements of a scene will invariably have more impact than a more complex picture. Always identify the things that appeal most strongly to you within the subject, and then consider which of the surrounding details you need to include, and which will only detract from the main interest. Doing this will usually involve making changes to both your viewpoint and the way in which you frame the image. You should also bear in mind that taking two or more photographs of a scene can sometimes produce more striking images than including everything in one shot.

Blue door

first view I have a fondness for doors and windows and have accumulated quite a collection of such photographs. They appeal to me because I like ordered images, and I find the symmetrical shapes of subjects like these, together with the textural quality of wood and stone, very satisfying. In places such as Morocco and India, many doors are works of art, decorated with rich colour and ornament.

in camera I spotted this door while travelling through a village in Morocco's Atlas mountains, and found the colour combination and decoration compelling. It was also shaded from the bright sunlight, which added to the intensity of the colours. To keep the image as symmetrical as possible, and avoid converging verticals, I took the photograph from a fairly distant viewpoint, using a long-focus lens to frame the doorway tightly.

35mm SLR camera; 70–200mm zoom lens; Fuji Velvia

49 Use colour harmony

When a scene contains colours that are in harmony with one another, the photographs you take of it will have a quieter and more restful quality than those of subjects with bold, contrasting colours. Colour combinations tend to be more harmonious when they come from adjacent bands of the spectrum, such as green with blue or orange with yellow, and when the colours are less saturated and have a muted, pastel quality. Subjects that have a strong textural quality, or those where a pattern is a dominant visual feature, often make more striking images when the colour content is quieter and more harmonious. Colour harmony can also help to create more atmospheric pictures.

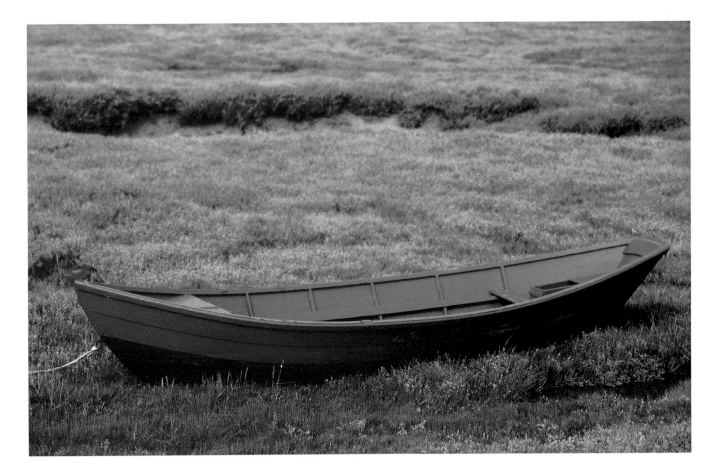

Blue boat

first view The combination of blue and green is a good example of a pairing that harmonizes well, and it is one that is commonly seen in nature, since these colours dominate the landscape and sky. However, I find that when they are combined out of this context they become more interesting. I was first attracted to this scene because of the ambiguity of the boat 'moored' in a meadow, but this is in fact a salt meadow in the north of France, which is covered each day by the incoming tide.

in camera I chose a viewpoint that allowed me to see into the boat, creating a good shape, and that was a little to one side to introduce some perspective. I framed the image so that the boat almost filled the viewfinder from side to side, and then angled the camera down until I felt there was a comfortable balance between the blue shape and the larger area of plain green above.

35mm SLR camera; 75–150mm zoom lens; Fuji Velvia

50 Photograph flowers in close-up

When shooting in colour, one way of producing images with powerful impact is to photograph flowers in close-up. There are few better sources of bold and interesting colour than nature, and flowers are always readily accessible, whether you go out to find them growing in the wild or in the garden, or buy them from a flower shop. Photographing plants where they are growing is an option, but you will have much more control over lighting, background and composition if you take flowers home and shoot them as still lifes, in either daylight or artificial light. You will need some means of focusing quite close, and this can be done by using a macro lens, extension tubes, a bellows unit or a close-up, supplementary lens.

Orchid

first view My wife Pat collects orchids, so at any one time we have at least a couple of plants in bloom. Occasionally, I am allowed to cut a stem. This makes it much easier to photograph and provides an opportunity to add a background of my choice. I was particularly taken by this spray of pink flowers and thought that it might go rather well with a piece of rusted metal I had recently retrieved from a junk yard.

in camera Having made the two main decisions it was simplicity itself to photograph. I set it up in my conservatory using the window blinds to control the direction and quality of the daylight. I used a large piece of white card to reflect some of the light into the shadows, to prevent them from becoming too dense. I angled the camera a little so that the stem was ranged along an almost diagonal line, and the blooms filled the frame.

Medium format SLR camera; 55–110mm zoom lens with extension tube; Fuji Velvia

Photographing people

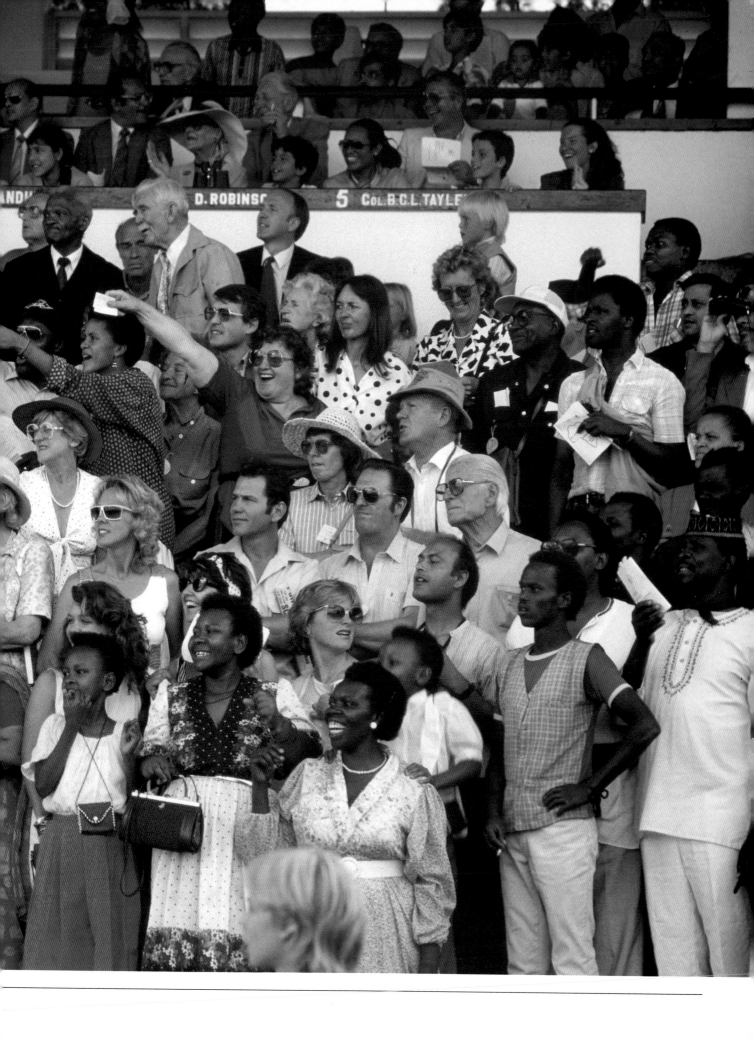

51 Take outdoor portraits in the shade

When portraits are taken outdoors, the light is generally taken for granted, but the quality of natural light can have a very marked effect on the outcome. In particular, bright sunlight can often create an unpleasant and unflattering portrait. On a sunny day, it is better to ask your model to move into an area of shade, where the light is much softer and will not produce the dense, hard-edged shadows and harsh contrasts that result from direct sunlight. The shade created by a doorway or the overhanging branches of a tree can be particularly pleasing, as it will shield the model's face from too much overhead light, which can make the eye sockets and the area under the chin appear dark.

Spanish man

first view I met this villager sitting outside the church on a sunny Sunday and was struck by his weathered face and good-humoured expression. He willingly agreed to let me take his portrait but, where he was seated, the sunlight was creating a harsh and unattractive quality, with dark shadows that obscured much of the detail in his face.

in camera I asked if he would mind moving into the shade of a nearby wall where the lighting was a lot softer and revealed his skin texture much more effectively. The light reflected from the sunlit wall opposite also contributed to the effect. I used a long-focus lens to frame his face quite tightly and made my exposure when he produced this rather amused and quizzical expression.

35mm SLR camera; 70–200mm zoom lens; Fuji Velvia

52 Use window light indoors

When taking photographs indoors, many people automatically use flash but, for portraits especially, the light from a small or built-in flash gun is seldom very satisfactory, and is limited in the way it can be controlled. Indoors, daylight can still be useful if your subject is placed reasonably close to a a good-sized window not exposed to direct sunlight. Unless the person is very close to the window, you may need to use a fairly fast film, say ISO 400, to avoid a slow shutter speed; even so, it's best to use a tripod. It will also help to place a large white reflector, such as a sheet of card or polystyrene, near the model on the opposite side to the window, to bounce light into the shadows and prevent the image becoming too contrasty.

Girl drawing

first view I took this picture in a room which was well lit by large patio doors. The two girls were seated quite close to the window and angled so the diffused daylight was directed from a little to the left of the camera. I took up a viewpoint that placed the camera more or less level with their faces, and framed the image quite tightly so that their heads were quite large in the frame and unwanted details at each side of them were excluded.

in camera The light level was quite good but I opted to use a tripod as it enabled me to leave the camera aimed and focused accurately while I concentrated on my models, who were happily engrossed in what they were doing. The shadows were a little darker than I would have liked, but using a reflector would have had little effect on the more distant girl, so I bounced the light from my flash gun off the white ceiling to create a better balance between highlight and shadow.

35mm SLR camera; 70–200mm zoom lens;
Kodak Ektachrome 100SW

53 Shoot from above your model's eye level

Many casual portraits are taken when both the photographer and model are standing up. It invariably results in a viewpoint that is level with, or may even be slightly below, the subject's eye level and this arrangement seldom provides the most pleasing or flattering view of a person's face. In the majority of cases, a viewpoint that is slightly higher than the subject's eye level, so that you are looking down on the other person, will produce a more attractive photograph and one that is more likely to please them. You are also likely to produce a better portrait if your model is comfortable and relaxed, something that is not easily guaranteed when they are standing. When you are shooting outdoors it's usually possible to find somewhere your model can sit, and this will achieve both aims.

Sri Lankan schoolgirl

first view I was taking a landscape photograph while travelling through Sri Lanka when a group of schoolchildren passed by and stopped to see what I was doing. I let a couple of them look through the viewfinder and they were highly amused. This little girl asked if I would take a photo of her. She had a very lively and interested expression and I thought that I might well get a pleasing picture.

in camera My camera was tripod-mounted and I didn't want to become too intrusive in case she lost her spontaneous naturalness so I simply aimed the camera down at where she was standing. I was using a long-focus lens at the time, so even for this tightly framed image I did not have to get very close to her. Consequently, the perspective was not greatly exaggerated, but I found that the slightly high camera angle enhanced her face and emphasized her rather cheeky expression.

35mm SLR camera; 70–200mm zoom lens; Fuji Provia 100F

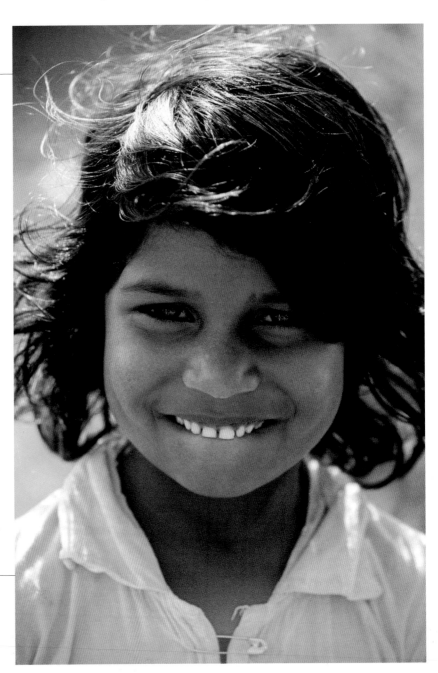

54 Don't get too close

It can be surprising how much the effect of perspective can change the appearance of a person's face. We are not really aware of it in normal circumstances, but when you place a camera close to someone's face, it will appear significantly different from the way they look from further away. If you take a photograph from where you might stand next to someone in conversation, say, their jaw and nose will appear too large in proportion to their head, and the effect is invariably unflattering. When you want to take a head-and-shoulders portrait, it is better to do so from a distance of at least 2m (6ft), and to use a long-focus lens to frame the image more tightly. Another consideration is that the camera can be intimidating when it is too close to a subject. With strangers in particular, this makes it difficult for them to feel relaxed.

Indian street performer

first view I met this man in Jaipur, in India, while he was waiting for a bus. He belongs to a cult who give street performances and, I imagine, had not had time to take his make-up off. He readily agreed that I could take his photograph. He was seated in partial shade, and the sunlight was diffused, which prevented it from being too contrasty, so I decided to photograph him where he was.

in camera I wanted to fill the frame with his head but was concerned that if I moved too close it would make him uncomfortable. It would also have created a distorted perspective. To overcome this, I fitted a long-focus lens and took up a viewpoint about 3m (10ft) away. I set a wide aperture which helped to throw the background details out of focus, preventing them from becoming too intrusive in the portrait.

35mm SLR camera; 70–200mm zoom lens with x 1.4 converter; Kodak Ektachrome 100SW

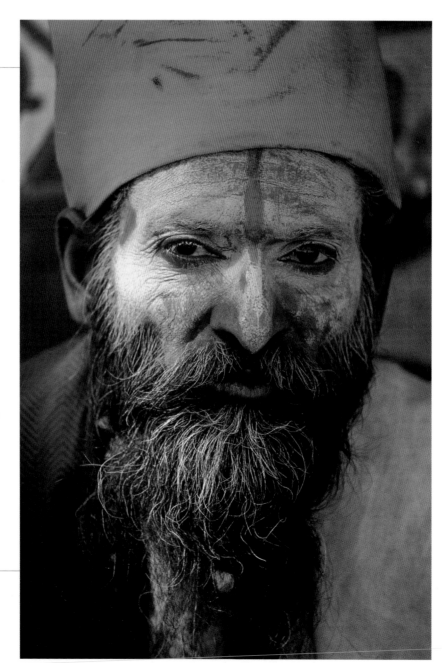

55 Consider the background

No matter how well your model is lit, how nicely composed the image and how pleasing the expression, the results will be disappointing if the background is not well chosen. Finding a suitable background outdoors can be a problem, as you want to avoid fussy and distracting details. It also needs to provide tonal or colour contrast, so that your model stands out clearly. A plain wall can be ideal, but a brick wall would be far too distracting. Foliage is too fussy when in sharp focus, but can be used if there is enough distance between it and the subject for it to be thrown out of focus, using a long-focus lens and a wide aperture. An area of deep shade, such as under a tree or in an open doorway, can make an effective background.

Clown

first view A small circus had set up near my home and I'd gone along to see what opportunities there might be to take some photographs. I began chatting to this clown who was preparing for his performance and, when I asked, he was happy to pose for some pictures. Finding a suitable background was important as the surroundings were not in any way photogenic – it was a very muddy field.

in camera The big top consisted of a rather tatty and grubby marquee made of plasticized canvas in red, white and blue, but it was really my best bet. I chose a blue section as the spattered mud showed up least clearly on the fabric and the blue also provided a bold contrast to my subject. I realized that the clown's trousers would become rather lost but I felt this would only help to focus attention on his face.

35mm SLR camera; 35–70mm zoom lens; Fuji Provia 100F

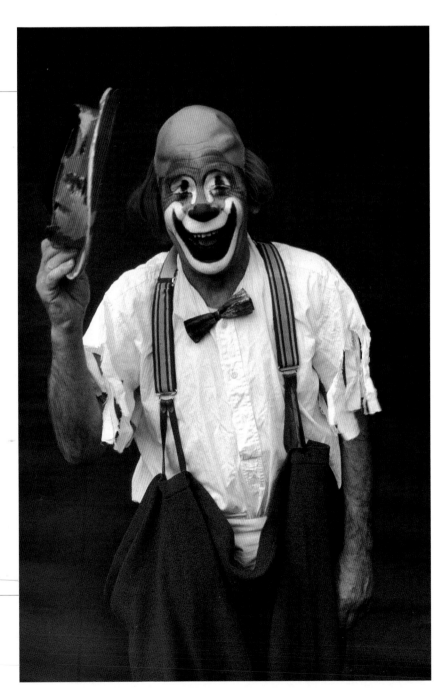

56 Shoot in black and white

It's no coincidence that many leading portrait photographers have opted to work in black and white. Skin tones can be difficult to record in a pleasing way in colour: just a hint too much red or blue looks unattractive, and blemishes that are barely visible to the eye can become very pronounced when recorded on colour film. The beautiful shots used in cosmetic advertising are invariably the result of painstaking make-up and skilful lighting. Shooting in black and white avoids this problem, and a monochrome portrait will stand out from the rest. With a film such as Ilford XP2 there is no need for a home darkroom, as it can be processed in most normal photo labs. Those with digital cameras or scanners can simply convert colour images to monochrome.

Man with turban

first view I had stopped for a drink at a roadside café while travelling in India and noticed this man's characterful, weathered face. When I asked his permission, he was happy to let me take his portrait. I asked him to move into a shaded area, where the diffused light was directed quite strongly from one side, in order to emphasize the contours of his face and the texture of his skin.

in camera I used a long-focus lens so that I could frame the image quite tightly without needing to be too close to him. I was quite tempted to include all of his rather fine turban but when I did so the image seemed a little unbalanced and his face became too small in the frame. I made several exposures while he was looking into the camera, but preferred this frame where he'd glanced to one side as it seemed more spontaneous and the lighting worked better.

35mm SLR camera; 70–200mm zoom lens with extension tube; Kodak Ektachrome 100SW

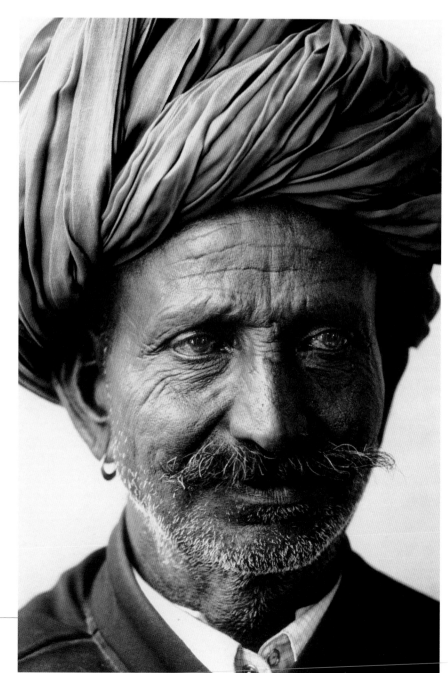

57 Shoot heads big

One sure method of photographing a person in a way that creates a considerable degree of impact is to fill the frame with their head. The 'head-and-shoulders portrait' is the image we are accustomed to seeing, and in this, the subject's face occupies a relatively small area of the picture. By literally filling the frame with the model's head, the impact can be hugely increased. To avoid exaggerated perspective you will need to use a long-focus lens from at least 2m (6ft) away, although if dramatic effect is more important than flattery a much closer viewpoint, perhaps combined with a low angle, can be worth exploring. Don't be afraid to crop into the head, showing only the face from just above the eyebrows, and consider too the possibility of tilting the camera to one side in order to create a more striking composition.

George

first view My friend George has a strong, lived-in face together with a shock of blond hair: both these attributes can help to produce an eye-catching portrait. I decided to use artificial lighting, as I wanted to be able to control it in order to emphasize his skin texture and to create a more dramatic effect than I could get with daylight.

in camera I used a single flash light, which was diffused by bouncing it from a large white reflector placed almost immediately to his right. I placed a similar white reflector on his left, quite close to him, to ensure that the shaded side of his face still retained some detail. The background was a roll of white paper. I tried framing the image in different ways until I arrived at this solution, in which I thought the balance between his hand, face and hair was right.

Medium format SLR camera; 105–210mm zoom lens with extension tube; Fuji Astia

58 Make use of a setting

In many portraits the background is something which, like 19th-century children, should be seen but not heard. But in some circumstances, the background can create an evocative setting for a portrait, not only contributing to the composition but also providing insight into the character and identity of the subject. A person's home or workplace can often say a great deal about them, and to photograph someone within such a setting can be an effective way of producing a picture with greater interest and a wider appeal. If you adopt this approach, it's important to see the subject as part of the overall composition, and to choose a viewpoint and frame the image in a way that creates a well balanced image in which the person you are photographing is the main focus of attention.

Indian schoolgirl

first view This was a case of the setting taking priority over the portrait. I had spotted this lovely old façade as I drove into the small Indian city of Jaiselmer and, after parking, decided to walk back and photograph it. When I arrived, I discovered that the building was the local school, and dozens of children were waiting to go in. Initially, my arrival created a bit of a stir and I became the focus of interest. But after a while the children's attention wandered and I was able to take some shots without them being aware of me.

in camera My main interest had been the building's ornately carved doorway, but this was where most of the children had congregated. Although I took a number of pictures there, I felt that the compositions were a bit too fussy. This young girl was sitting to one side and the wall behind her had a lovely colour and texture. I was some distance away and it was easy to redirect my camera without attracting her attention. I framed the scene so that she was placed within the image in a way that created a nicely balanced composition.

35mm SLR camera; 24–85mm zoom lens; Fuji Velvia

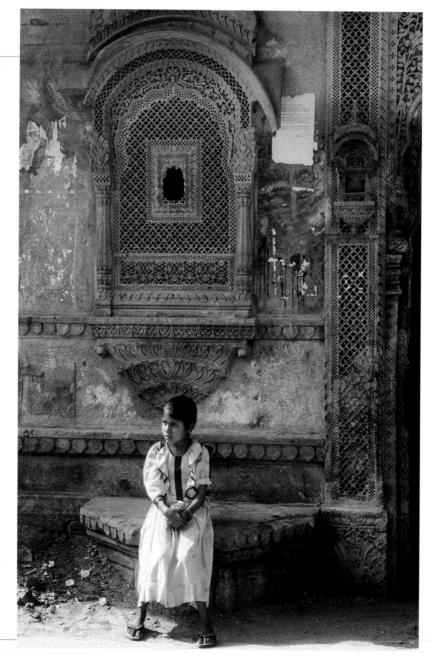

59 Photograph people at work

One of the difficulties of photographing people, even those you know quite well, is making them feel at ease. A good way of overcoming self-consciousness is to photograph them while they are working or occupied with a familiar task, as this tends to give them confidence and also encourages them to feel that they are not the sole object of your interest. You need to ask them to adopt a position that will show their face fairly clearly, or choose a viewpoint that achieves the same end. Be careful that the setting, or the activity, does not become too intrusive, and that the person remains the main focus of the image. As well as being a good way to photograph friends and family, this is a good approach for portraits of strangers.

Goose lady

first view While shooting pictures for a book on France, I visited a goose farm. Unlike many other forms of livestock farming, geese are often still raised in a very old-fashioned way. I was allowed free run of the farm and took a number of images showing the birds and their surroundings, but was keen to shoot something with a more personal feel. This lady was a perfect portrait subject but was rather shy of being photographed. My attempts to put her into pictures I'd set up only resulted in looking contrived.

in camera My chance came when it was time to feed the young geese. As soon as she appeared with her bucket of meal, the birds came running and swarmed all around her. This was obviously a very familiar and enjoyable part of the day for her, and she very soon seemed to forget I was there, leaving me free to find some good viewpoints and take much more relaxed-looking photographs.

35mm SLR camera; 35–70mm zoom lens; Kodak Ektachrome 100SW

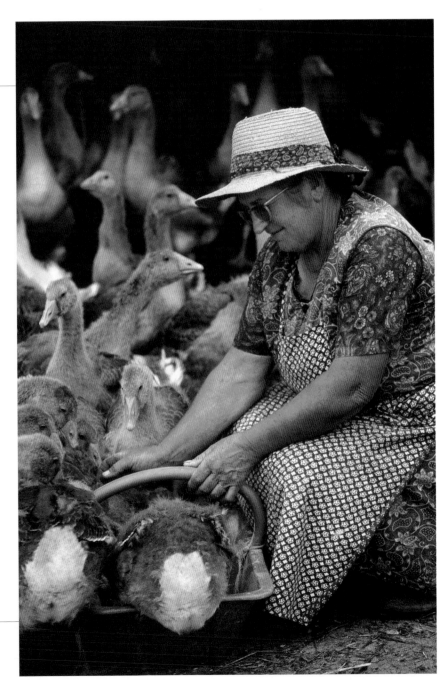

60 Shoot candid portraits

While having your subject pose for the camera is the most common approach, it can result in rather static and self-conscious portraits. More spontaneous results can be achieved by shooting when your subject is unaware of the camera, or unprepared. You need to be very familiar with your equipment, as the opportunity for a good shot may exist for only a few seconds. This approach is most difficult to adopt when shooting in foreign locations, when your presence is often only too obvious to your intended subject. It is best to allow some time before you start taking photographs, as interest in your presence will invariably be short-lived. It also helps to keep a low profile, and not to have your camera in full view until it is needed.

Girl with sheep

first view I spent some time in Israel some years ago and had the opportunity to visit a Bedouin market held in a town on the edge of the desert. It was my first experience of a gathering like this, and I found it quite overwhelming, but bursting with photographic possibilities. I think I was the only westerner there and all eyes were turned towards me. It seemed that I would have little or no chance of shooting any candid pictures.

in camera However, after a very short time I found that my presence ceased to be of interest. Everyone carried on with what they were doing and took little further notice of me. I had left my camera bag in the car, putting some spare film and lenses in my pockets, and I found that I was soon able to mix in with the crowd without attracting much attention. This young girl was too concerned about her sheep to even notice me, and having found a good viewpoint I was able to raise the camera, frame and shoot without her even noticing.

35mm SLR camera; 75–150mm zoom lens; Kodak Ektachrome 100SW

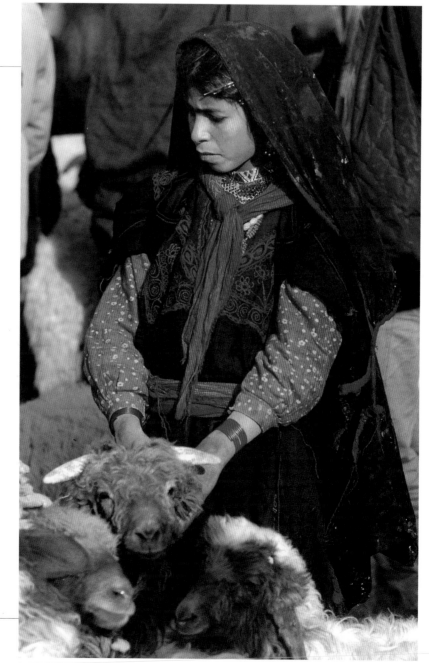

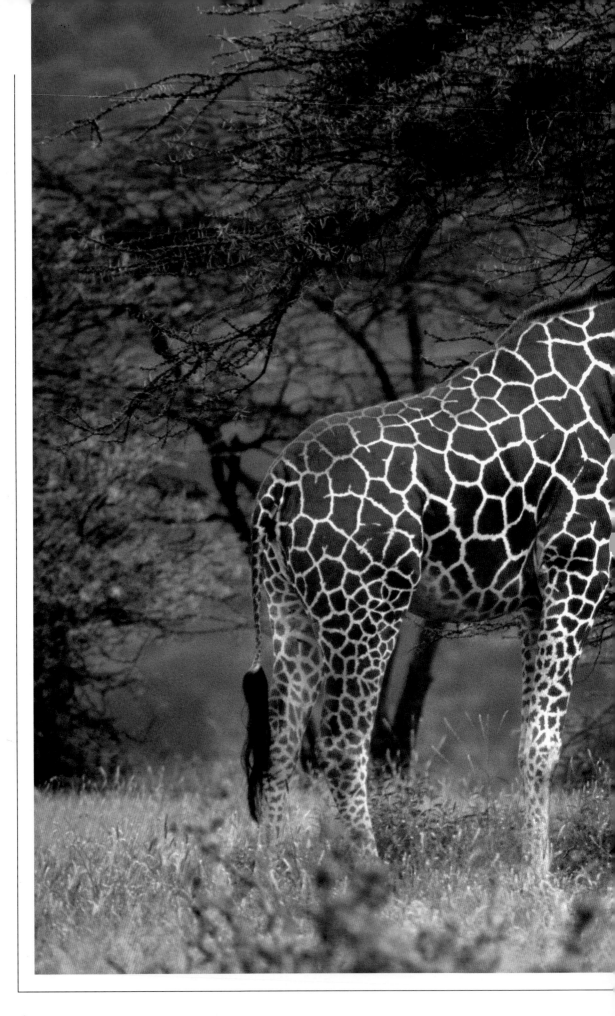

Photographing nature

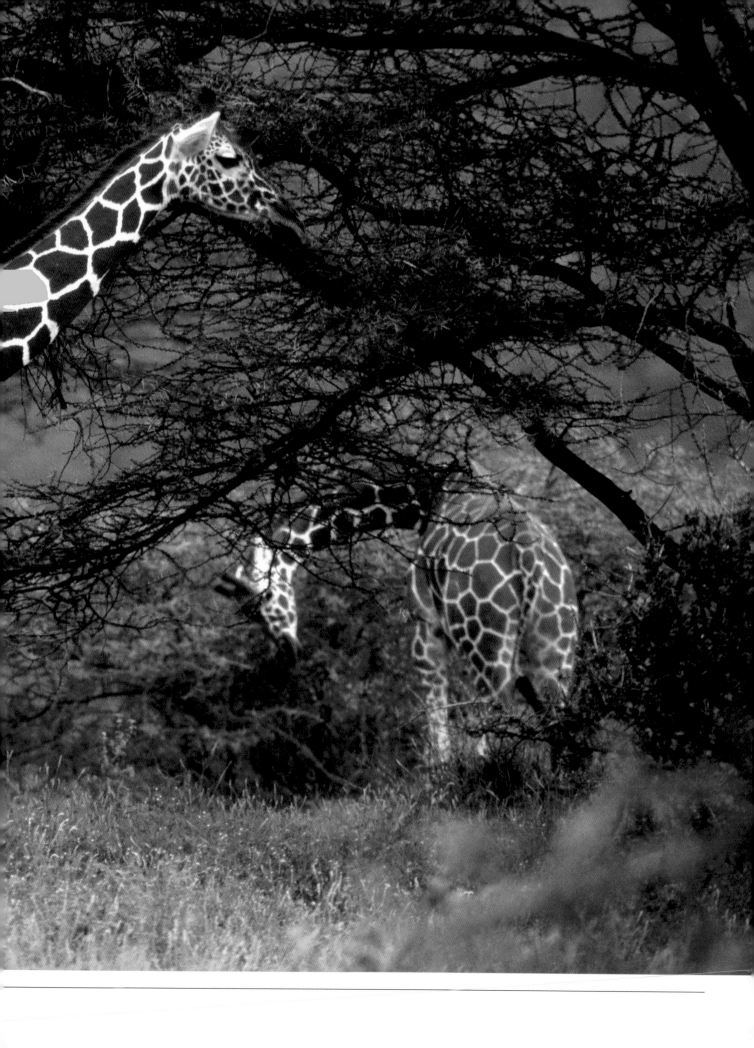

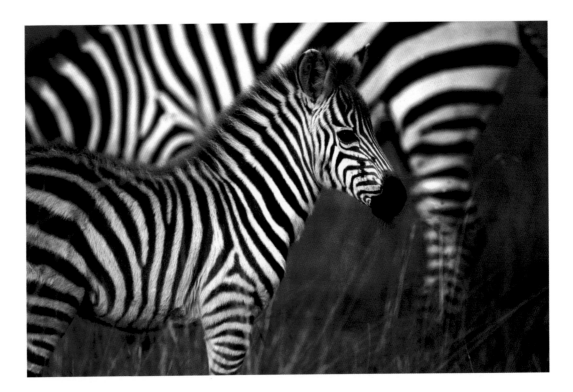

61 Fill the frame

Look through any book or magazine with photographs of animals, and those that tend to stand out from the rest are the close-ups. Like children, animals have a universal appeal, which largely stems from their facial expressions. Framing your subject quite tightly makes the most of this, and also emphasizes the subtleties of texture in fur and feather. Of course, you need to get quite close to your subjects for pictures like these and, as a rule, you will need a long-focus lens to isolate the most important features. While photographing most animals in the wild is something for the specialist, it is possible to get very close to animals in a setting such as a safari park, and a well established bird table in your garden will offer opportunities.

Young zebra

first view I took this photograph on safari in Kenya, where it is possible to approach many of the animals quite closely in a vehicle. But shooting from a vehicle can present a few difficulties and, on this occasion, I was using a very heavy and bulky 600mm lens. I'd spotted this young zebra with its mother and felt there was the possibility of a good shot if I could find a viewpoint where I could make the youngster the main subject, with the parent as background.

in camera Shooting from the roof hatch, with the lens supported on a bean bag, I asked my driver to move into a position where the adult animal could be seen behind the young one. In fact, with the lens I was using, I was a little too close and the image was cropped too tightly, so I had to ask him to back up a little. The light was quite soft as the day was overcast – ideal for quality, but not bright enough to allow a really fast shutter speed – and I was concerned about the possibility of camera shake with such a long lens. I made sure that there was no movement in the vehicle and pressed the lens firmly into the bean bag before shooting, and all the images were perfectly sharp.

35mm SLR camera; 600mm lens;
Fuji Provia 100F

62 Photograph natural forms

Flowers, trees, animals and birds are understandably popular subjects for photographers, but there are many other aspects of nature that offer great potential for making striking photographs. Shape, pattern and texture are elements that can create powerful images when they are harnessed effectively, and natural forms such as trees, leaves, rocks and water are especially rich in such qualities. By isolating small areas of subjects like these it is possible to produce pictures that have an abstract, almost painterly quality. In these photographs the subject may become less significant than the composition. When small details of natural forms are seen in close-up, they may take on a sense of scale more akin to a landscape.

Sand pattern

first view I photographed this image on a beach in north Devon through which a small stream runs. It carries a film of dark silt which, at low tide, is deposited onto the much lighter coloured sand. This process creates an endless variety of interesting patterns and textures. On this occasion, in the early morning, the sunlight was at a low angle and had highlighted the sand ripples in a striking way. In addition, the shaded area of the wet sand was reflecting the blue sky, which had created a colour change.

in camera I found a viewpoint that allowed me to frame the most interesting part of the pattern. I set my tripod as high as it would go, and used a wide-angle lens to look almost directly down on the sand. I angled the camera so that the main lines of the pattern fell on the diagonal, and framed the image to include a little of the blue tinted area at the top. I used a polarizing filter to accentuate the pattern and the colour difference.

35mm SLR camera; 24–85mm zoom lens with polarizing filter; Fuji Velvia

63 Take advantage of garden design

A garden is a contrived landscape that is designed to create a series of well composed and balanced scenes. Because of this, a visit to an attractive garden is very likely to offer numerous photographic opportunities within a relatively small area, something that the open countryside rarely does. There are a number of possible approaches to photographing a garden, depending upon the nature of its design and the time of year, as well as the lighting and weather conditions. Relatively close-up pictures of features, borders and individual plants can be very effective, but for a more scenic approach that conveys the character of the garden as a whole, try to find a clear focus of interest and introduce foreground details to create a sense of depth and perspective.

English garden

first view I came across this traditional English country garden surrounding a beautiful stone cottage while shooting landscapes in Wiltshire. It was a private garden but, on being asked, the owners were happy for me to take some photographs. It was late in the afternoon on a sunny day, and the low angle and warm quality of the sunlight had created some good texture and emphasized the rich colours of the flowers.

in camera There were some quite large areas of shadow, and my choice of viewpoint was partly determined by the need to limit the amount of shadow included in the image. But I also wanted to use the large stone surrounded by flowers as a foreground feature. I framed the image, using a wide-angle lens, so that most of the deep shadow on the left was excluded, and a little of the small stream running through the garden was included. I set a small aperture to ensure the image was sharp from front to back.

Medium format SLR camera; 55–110mm zoom lens; Fuji Velvia

64 Use the sky as a background

One of the keys to success in making an eye-catching photograph is finding a way to keep the image simple and avoiding too many details that would create confusion. In this respect, the background is often the aspect of a composition that causes the biggest problem, especially when you want to make your subject stand out clearly. A good way to provide a plain, uncluttered background is to use the sky. It's usually necessary to take up a low viewpoint in order to do this but, with some effort, it is even possible to use the sky in this way when photographing individual plants and blooms. There is, however, a danger that including a large area of sky will suggest less exposure than is actually needed; it is best to take a close-up or spot reading from a mid-tone in the subject.

Goat

first view I photographed this fine creature in Corsica, which is home to a particularly photogenic species of goat, all of whom seem to have permanent expressions of superiority. I had made several attempts to photograph them, but it was difficult to get close enough and they were usually in situations where the nature of the setting did not allow them to stand out clearly from the background.

in camera I encountered a small herd while driving through the mountains, where the road was bordered by steep, grassy banks. As I approached my chosen victim he, or she, started to move away but the only way was up. So, fitting a long-focus lens I pursued him, or her, gently until the animal broke the horizon line. Here the deep blue sky provided an ideally uncluttered and contrasting background.

35mm SLR camera; 70–200mm zoom lens;
Fuji Velvia

65 Choose trees as subjects

Trees are not only lovely to look at, they also make wonderful subjects for photographs. They provide striking elements of contrast in the natural landscape, because they create bold vertical lines and shapes against the essentially horizontal contours of the land. A single, isolated tree can produce an especially strong image when it is clearly defined and uncluttered by background details. A tree on a distant horizon, for instance, can become a compelling focus of interest even when it is quite small in the picture, and a low angle that displays the shape of a tree against the sky can be very effective. Trees are particularly satisfying to photograph in the winter, when the structure of the bare branches is revealed.

Gum tree

first view I saw this skeletal gum tree while driving through the Flinders Range in south Australia. Although there were plenty of gum trees around, this one stood out because of the way its elegant shape was thrown into strong relief by the late afternoon sunlight. I chose a viewpoint that created the best juxtaposition of the branches, and placed it against the plain, contrasting tones of the bank and the blue sky.

in camera I framed the image in order to focus attention on the shape of the branches and trunk. I used a polarizing filter to make the colours of the sky and soil richer, with an 81B warm-up filter to accentuate the red hues of the image.

35mm SLR camera; 24–85mm zoom lens with polarizing and 81B warm-up filters; Fuji Velvia

66 Make the most of autumn colour

If there is a best time in the year to take photographs of the countryside, it has to be autumn. The rich, warm colours and textures of the foliage, combined with the mellow light, will guarantee an eye-catching photograph if you follow a few rules. Don't attempt to show too much of a scene, as the result can easily become too fussy and distracting. This is especially true when shooting in sunlight, as too many bright highlights and dense shadows can create chaos within the detail and texture of trees and foliage. One way to make sure of a winning shot is to photograph a relatively small area of woodland, where the colour is strong, on an overcast day when the light is soft.

Leaf fall in Compiègne

first view A beech forest like this offers some of the richest autumn colour, and it was near its peak in late October. It was a gloomy, overcast day with light rain but inside the wood, the soft, almost shadowless light enhanced the golden hues. I looked for a viewpoint where the tree trunks were nicely aligned, and framed the shot so that the foreground tree trunk became the focus of attention and those in the background were nicely balanced around it.

in camera I framed the picture quite tightly, so that only the essential elements were included. Setting my camera on a tripod enabled me to use a slow shutter speed and a small aperture to get good depth of field. I used a slow film, Fuji Velvia, with a polarizing filter to increase the colour saturation and a warm-up filter to enhance the reddish hues.

Medium format SLR camera; 55–110mm zoom lens with polarizing and 81B warm-up filters; Fuji Velvia

67 Photograph flower portraits in situ

While it is much easier to pick flowers and photograph them under controlled conditions, it is often desirable to shoot them growing in their natural surroundings. With small blooms growing close to the ground you will need some way of supporting the camera very low down. Although some ordinary tripods allow this, it may be easier to buy a small tabletop tripod for the purpose. Lighting needs to be quite soft, with an absence of dense shadows and bright highlights, so direct sunlight is best avoided. For close-up pictures you can use an umbrella or a piece of card to cast a shadow over the subject. The background should be unobtrusive and with a tonal or colour contrast that makes the subject stand out clearly.

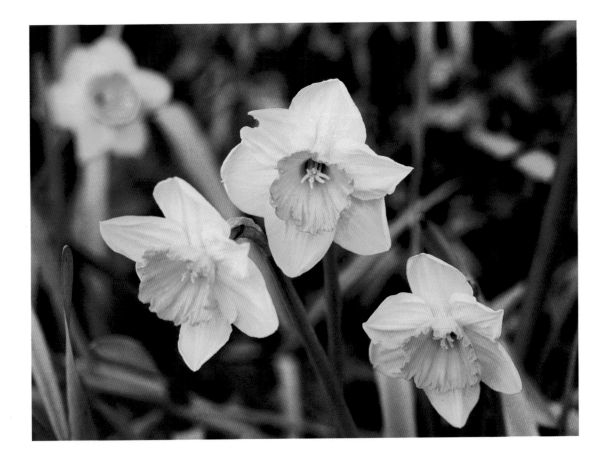

Daffodils

first view These blooms were in my own garden, so I was able to choose a time when they were fully open and in good condition. It was a sunny day but the flowers were in an area of open shade under a tree which provided an ideally soft light to illuminate the blooms. The stems of the plants were reflecting the sky giving them a noticeable blue cast which made the bright yellow bloom stand out boldly.

in camera I chose a viewpoint that separated the three foreground flowers and placed the fourth, background bloom in a nicely balanced position. I used a long-focus lens from a fairly distant viewpoint to compress the perspective and also to reduce the depth of field, as I did not want the background details to be too sharp. I set an aperture that was small enough to ensure that just the three foreground blooms were in sharp focus.

Medium format SLR camera; 105–210mm zoom lens with extension tube; Fuji Velvia

68 Get up close to farm animals

A few hours spent on a farm can produce some great animal photographs. Naturally you must ask permission and make sure you don't cause any disturbance but, with the right approach, many farm owners will be happy to co-operate. Most farm animals can be approached closely without difficulty, which makes shooting portraits easy, but it will add interest to your pictures if you also show something of the setting and the animal's behaviour, to capture the atmosphere and activities of farm life. One thing that will always give your pictures added appeal is to photograph young animals, and it's well worth timing your visit to take advantage of events like lambing, or the birth of foals or calves.

Piglets

first view I had been commissioned to shoot some pictures for a brochure advertising farm holidays and had been lucky enough to visit some interesting establishments where the seasonal activities on the farm would be part of the attraction for visitors. It was pure luck that when I arrived at this farm a litter of piglets had very recently been born.

in camera After I had photographed some of the piglets individually, they very obligingly lined up neatly to offer me a different kind of picture. Daylight falling on them through the barn doors created a nice effect and I needed only to find a good viewpoint. Some height was needed so I stood on my rigid camera case in order to shoot down on them a little using a wide-angle lens. I framed the image so that it was filled by the piglets, and tilted the camera just a little so they formed a diagonal line, setting an aperture that ensured the image would be sharp overall.

35mm SLR camera; 20–35mm zoom lens; Fuji Provia 100F

69 Photograph pets

With a pet you have the chance to take much more intimate animal photographs than you are likely to have elsewhere. While photographing a pet can provide excellent opportunities for close-up portraits it can also be rewarding to shoot more spontaneous pictures which show more of an animal's character and behaviour. A series of such photographs could be used to create a sort of visual diary on the lines of – 'A day in the life of' – and is also likely to offer the chance to shoot pictures with a touch of humour. It can often help when photographing animals to do so at their level and this will also produce a more intimate feel. Patience is a considerable virtue with animal photography and the more time you spend the more you are likely to take winning pictures.

Tiffy

first view My cat Tiffy is a strange little animal who has some very odd mannerisms. One of them is to suddenly hurtle up the stairs, for no apparent reason, while uttering a low growl which wouldn't seem out of place coming from the Hound of the Baskervilles. I've always intended to try and photograph some of her more eccentric behaviour but never have until now.

in camera Tiffy has the habit of wandering into the sitting room during the evening and taking up central stage on the carpet where she proceeds to carry out a grooming regime. For several evenings I kept my camera and flash all set ready beside me on the sofa and waited for the action to begin. On my first attempt she simply stopped, got up, and stalked out of the room. But as I persisted on subsequent evenings she seemed to accept it and let me shoot some frames. I used flash bounced from the ceiling.

35mm SLR camera; 24–85mm zoom lens; digital capture at ISO 400 setting

70 Concentrate on close-ups at the zoo

A zoo offers opportunities to photograph wild animals at close quarters, but it can be difficult to get an unobscured view and avoid showing the fact that they are confined. If you concentrate on close-ups using a long-focus lens, background details can be kept well out of focus. Wire fences can be rendered invisible by placing the camera very close to them and using a wide aperture, and this is also the best way of shooting through glass to avoid reflections. However, showing animals within the zoo environment can also produce good pictures when the setting is interesting enough to use as an element of the composition. Check feeding times, as this is when the animals are likely to be most visible and accessible.

Gorilla

first view I photographed this nice old fellow during a visit to Port Lympne zoo in southeast England. This zoo is noted for its collection of gorillas and accommodates them in a particularly fine house with huge glass walls, to which you can get very close. Feeding time here is one of the zoo's highlights and I didn't want to miss it. The viewing area can get crowded but it was winter and I had little trouble in finding a good viewpoint.

in camera I took a number of photographs that showed the animals within their setting but I was keen to have a shot that did not make their captivity too obvious. I had picked out one particular gorilla who seemed especially photogenic, and watched his movements for a while before settling on a viewpoint. I then fitted a long-focus lens and, holding it as close to the glass as possible, waited for him to move into the right position before focusing on his eyes and shooting.

35mm SLR camera; 100–400mm zoom lens; Fuji Provia 400F

Still life and close-up

71 Keep still life simple

A still life must have a starting point: an interesting idea, object, theme or setting. The most basic form of still life is what professionals describe as a pack shot, which could be anything from an elegant perfume bottle to a can of soup. Much more elaborate arrangements can be seen every day in magazines and catalogues, but the main criteria are always the same: the image must be nicely lit, well composed and visually appealing. It often pays to keep it very simple and direct, and the most striking still-life images invariably have a strong element of design. It's best to begin with a single main object and a background or setting that enhances it, and then to add any other elements needed to build a satisfying composition.

Fiddle and pipe

first view The starting point for this photograph was the fiddle, a primitive instrument I'd found in the souk in Marrakech. It has many of the qualities that can make a memorable still-life image: it's an interesting object with a pleasing shape and contrasting textures. My first thought was to restrict the image to the fiddle with its bow, set against a plain background, but I felt this composition might lack interest and impact.

in camera I decided instead to use a piece of decorative embroidered fabric I'd bought in India to add further elements of colour and of texture, while harmonizing with the ethnic character of the instrument. I still needed to add something more – as a general rule, an odd number of objects makes a more satisfying composition – so I added a small decorated whistle. I used window light indoors, with a white reflector to prevent the shadows from becoming too dark.

35mm SLR camera; 24–85mm zoom lens; digital capture at ISO 100 setting

72 Emphasize texture with lighting

The photographic process can record surface texture with almost uncanny accuracy, to the point where it can be hard to tell a photograph from the real thing. Interesting, and perhaps contrasting, textures give an image impact when they are emphasized. This is partly dependent upon scale: a smooth fabric, for example, can be seen to have a strong texture when photographed very close up. But emphasizing texture is also a matter of lighting. A very subtle texture needs a strong, acutely angled light to reveal it, whereas a coarsely textured surface requires a softer and more frontal light. In practice, the textural quality of the subject is usually only one element of the image and it's necessary to strike a balance.

Crackers

first view These rather ancient nutcrackers have, for me, an appealingly weathered and worn texture as well as an interesting shape, and I thought they would provide a good starting point for a small still life in which texture would be a dominant element. At first I tried the effect of a coarsely textured basket as the background but this proved to be too overpowering, and it was also too dark in tone.

in camera A piece of folded muslin created the best effect, as its light tone made the darker objects stand out more strongly, and the subtle texture of the fabric emphasized the harder shapes and textures of the nuts and the metallic quality of the crackers. I used daylight indoors to illuminate the arrangement, which was set up quite close to a window, and angled so that each of the different textures was effectively revealed.

35mm SLR camera; 100mm macro lens; digital capture at ISO 100 setting

73 Look for pattern

Pattern can be used to produce images with a satisfying, balanced effect that the eye finds comforting and reassuring. A pattern is simply the repetition of a particular shape or detail, and it doesn't necessarily have to be exactly the same shape; as long as there is a similarity the eye will recognize the rhythm of the pattern. Numerous examples of patterns occur in nature, especially when natural forms are seen in close-up, and manufactured objects also offer plenty of opportunities to discover patterns. While an image consisting only of a pattern has an initial impact, interest is more likely to be sustained if there is another element within the image to act as a focus of interest, in effect breaking the pattern. The impact of a pattern is usually heightened when the subject of a photograph has a limited colour range.

Wooden stakes

first view I was travelling through vineyard country in France when I came across a village where they were making the stakes used to support the vines, and saw this impressive stack beside the road. It was a cloudy day and the light was diffused, so there were no dense shadows or very bright highlights to confuse the image, which was quite complex.

in camera The pile of stakes was very large and my first inclination was to include all of it in my picture. I set up the camera using a frontal viewpoint. This not only gave the clearest view of the bundles but also eliminated any sense of perspective which, I thought, would detract from the effect. When I looked through the viewfinder I realized that the pattern would have more impact if I selected a smaller area, in which the two different patterns created by the tops and points of the stakes were intertwined.

Medium format SLR camera; 105–210mm zoom lens; Fuji Velvia

74 Make use of shapes

An object with an interesting shape can be a powerful element in a composition. Even a clearly defined silhouette can be effective in an image. The best way to emphasize the shape is to ensure that there is a strong tonal or colour contrast between subject and background. This contrast may be inherent in the arrangement, as with a red tomato on a blue plate, and contrasting one shape with another, such as placing a round object in a square box, is another device that will create an eye-catching image. Alternatively, contrast can be created by lighting an object more strongly than its background, or vice versa. Focusing can also emphasize an object's shape, if it is in sharp focus while background details are very blurred. This is most easily done using a long-focus lens set to a wide aperture to restrict depth of field.

Earthenware vase

first view I'd bought this rough-textured vase from a small village pottery in Spain, and thought at the time that it would make a good subject for a still life because of its pleasing shape. When considering a suitable background I realized that this rag-painted wall would give the image some warmth and would also be in keeping with the rustic quality of the vase. Instead of using fresh flowers, I cut two sprays of dead hydrangea blooms, in tones similar to those of the earthenware. I stood the arrangement on a piece of leather, whose colour also harmonized with the wall and the vase.

in camera I placed the vase near the wall, but far enough away for the light to pass behind it. I lit the arrangement using a soft box almost at right angles to it, and placed a large white reflector on the opposite side to bounce some light back into the shaded areas in order to prevent them from recording as pure black.

35mm SLR camera; 24–85mm zoom lens; digital capture at ISO 100 setting

75 Photograph translucent objects

A relatively simple way to produce unusual images is to photograph translucent objects using a light box. Leaves, flowers and numerous common household objects will allow enough light to pass through them to make striking photographs. An ordinary photographic light box is ideal, but you can also set up a makeshift arrangement using glass supported about 1m (3ft) above a large sheet of white paper, which should be lit evenly so that light does not spill onto the glass. Depending upon the object's translucency, the effect may be improved by adding some reflected light from a source above the light box. Adjust its brightness, or distance from the subject, to create a pleasing balance between the reflected and transmitted light.

Ice crystals

first view Very interesting colour effects can be produced when translucent objects are lit by polarized light and then photographed using a polarizing filter. Some transparent plastic will produce startling colours in this way, as will certain crystals, including ice. If the effect is not very striking using a single object, a combination may produce a more eye-catching result.

in camera This image is of a plastic CD cover, over which I placed a thin sheet of ice, made by freezing water in a saucer. My light source was a photographic light box covered by a large sheet of polarizing acetate (available from scientific suppliers). This filter must be large enough to cover the area occupied by the object. I also placed a polarizing filter over the camera lens. By rotating the ice, the CD cover and the camera's polarizing filter it was possible to obtain a wide range of effects. I used a macro lens to produce a larger-than-lifesize image.

35mm SLR camera; 100mm macro lens; digital capture at ISO 100 setting

76 Use food as a subject

One of the most photogenic subjects for still-life photography is also one of the most readily available – food. Apart from the fact that food is of considerable interest to most of us, it is satisfying to photograph because it includes so many pleasing shapes, rich textures and interesting colours. One of the best known still-life photographs is a simple image of a pepper by Edward Weston, demonstrating that you don't need a complex arrangement with props and elaborate backgrounds to create a striking image. A few minutes selecting some choice pieces of fruit or vegetables in a supermarket can provide enough material for a number of photographs, needing only simple lighting provided by daylight and perhaps a reflector.

Mediterranean fish

first view Fish shops and market stalls in the Mediterranean are often full of colourful and interesting subjects for still life. During a holiday on the Costa del Sol, I used to buy an assortment of fish to cook for dinner, and on this occasion, the selection was so good that I thought about making it the subject of a photograph. Because of this I based my choice on the photogenic qualities of the fish, making sure that I had a good range of colours and shapes.

in camera I'd found a piece of driftwood on the beach, part of a derelict fishing boat, which I thought would make a suitable background. As it was a slightly overcast day, the light was quite diffused. This was ideal as the subtle textures and colours would have been lost with lighting which created dense shadows. Starting with a single fish, I added the others one at a time, adjusting their positions within the frame until I achieved a nicely balanced and cohesive arrangement.

Medium format SLR camera; 55–110mm zoom lens with extension tube; Fuji Velvia

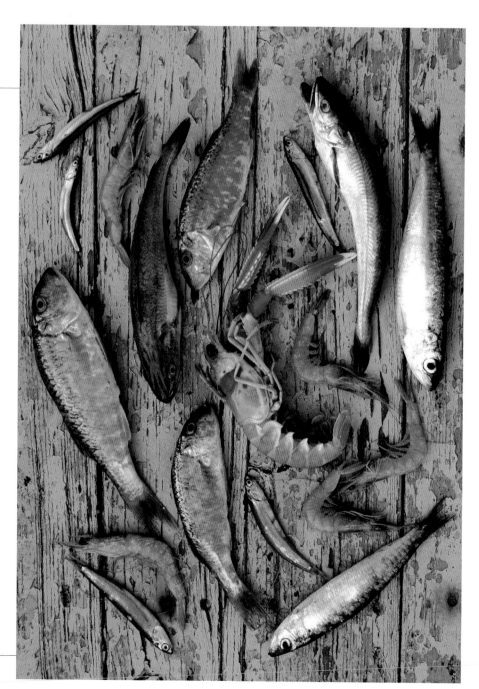

77 Take the abstract approach

Close-up photography allows you to produce pictures that have an abstract quality and are not simply a record of an identifiable subject. This can be an effective approach if you are interested in exploiting the visual elements of a subject as a means of creative expression. Even the most familiar objects found around the home and garden can be photographed in original ways to produce intriguing and eye-catching images. Choosing an unusual viewpoint, and framing the image so the subject is not clearly identified, will preclude any preconceptions about the subject, and make the viewer focus on qualities such as shape, pattern, texture and colour. Lighting can also help to add an air of mystery and give the image greater impact.

Crumpled paper

first view The idea for this picture was triggered by seeing something another photographer had produced. He had rolled a sheet of white paper into a cone and placed it on a black background, then lit it quite softly from an acute angle, creating a beautifully graduated range of smooth tones from white to pure black. It looked very elegant. Naturally, I did not want to copy this idea slavishly, but I liked it and began by simply crumpling a piece of white paper.

in camera I used a single diffused light from one side, but was disappointed with the effect as, even when the image was tightly framed, you could see instantly what it was and I wanted it to be more abstract. I then thought of putting the crumpled paper onto a light box so that it stood up, which caused it to be lit strongly but softly from underneath. This looked much more encouraging and I played around with it for a while, tilting and twisting the paper until I arrived at the image you see here.

35mm SLR camera; 100mm macro lens; digital capture at ISO 100 setting

78 Mix transmitted and reflected light

Glass, like water, both reflects and transmits light, and this can be used to create very subtle tones and textures. Transmitted light is best exploited by placing the glass object in front of a strongly lit white background, or a translucent white material, such as tracing paper, lit from behind. With a multi-faceted object you can produce a variety of effects by changing the background lighting. Even lighting gives a limited range of tones, but a pool of stronger light produces a much greater tonal variation, and the detail within the glass will be more clearly defined. The reflective qualities of glass are most effectively revealed by using a diffused light from the front of the set-up, such as a soft box or light bounced from a white reflector.

Bottle and glass

first view I began by placing a glass shelf about 2m (6ft) in front of a roll of white background paper. Using two studio flashes, one on each side behind the glass shelf, I lit the background as evenly as possible, ensuring that no light spilt onto the shelf. With the bottle and glass in place, I then placed another flash, which was diffused by a soft box, close to the set-up on the left-hand side, adjusting its position until it created areas of highlight on the front of the glass which revealed its shape and texture.

in camera I set up the camera and framed the image quite tightly, adjusting the angles of the glass and bottle until I found the optimum positions. In order to create a little more detail on the glassware I placed a white reflector on the opposite side of the arrangement to the soft box. Just before I made my exposures I made a note of the exact position of the glass, removed it, filled it with beer and then quickly replaced it before the head collapsed.

Medium format SLR camera; 105–210mm zoom lens with extension tube; Fuji Velvia

79 Look for ready-made still lifes

While it can be both satisfying and enjoyable to arrange your own still-life set-ups at home, there are plenty of opportunities to take advantage of other people's efforts, as well as finding fortuitous arrangements. With this type of still life the image must be composed by the choice of viewpoint and framing. A tripod is a valuable asset for pictures of this type because not only will it enable you to use smaller apertures for good depth of field, it will also allow you to control the framing and viewpoint more precisely. Subjects like this often depend upon qualities like colour and texture for their impact, and the softer light of a hazy or overcast sky is usually preferable to a sunny day when the shadows are dense and the contrast high.

Indian spices

first view I have spent many a happy hour wandering around markets with my camera. They can be excellent places for shooting ready-made still lifes, since they are full of carefully arranged displays of produce. I can't imagine how long these spices took to set up in an Indian street market – the proprietor must have been up before dawn.

in camera It was early in the morning and although it was a sunny day this part of the market was still in shade and the light was ideally soft, creating good form and texture but lacking excessively dense shadows or contrast. The display had been constructed so that it looked its best viewed squarely, but I needed to get my camera as high as I could, using a wide-angle lens, to show as much of its extent as possible. I used a small aperture to obtain good depth of field and sharp focus from front to back.

35mm SLR camera; 24–85mm zoom lens; Kodak Ektachrome 100SW

80 Create design with colour

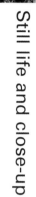

One of the most satisfying aspects of photographing subjects such as portraits and still lifes is that you have great control over the content and composition of your pictures. This can be especially useful when it comes to using colour effectively. Your choice of colour for backgrounds and props can play a central role in creating a strong sense of design in your pictures as well as the mood they evoke. Including objects with a bold colour contrast will give an image a lively and eye-catching quality, whereas softer, more harmonious colours will produce a quieter, more reflective mood. Colour can also play a vital part in creating a strong focus of interest, ensuring that the viewer's eye is drawn towards a specific part of the image.

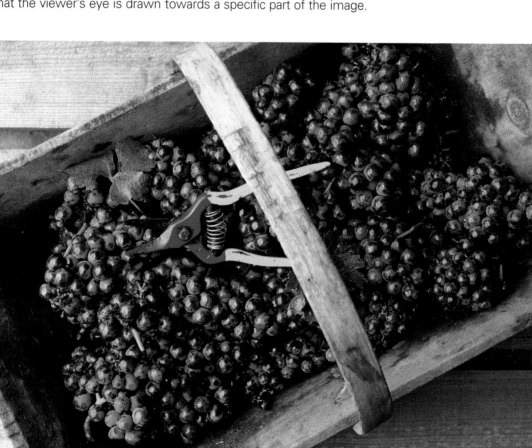

Basket of grapes

first view The opportunity for this picture arose when I was commissioned to shoot photographs of the wine harvest in France. In the very best vineyards the process of selecting the grapes is carried out most rigorously, and I realized that I had the choice of some of the best-looking wine grapes I was likely to see anywhere. I borrowed one of the picker's baskets and filled it with the best bunches I could find.

Medium format SLR camera; 55–110mm zoom lens with extension tube; Fuji Velvia

in camera I set the picture up just inside the doors of the winery so it was lit by diffused daylight at an acute enough angle to create quite strong shadows and highlights on the grapes. This emphasized their shape and texture. I shot from immediately above the basket, in order to see right into it, and framed the image so that the grapes occupied a large area. The image needed a focus of attention and, at first, I used a sprig of vine leaves, but this was not bold enough. The grape picker's shears were exactly the right colours, and I placed their fulcrum near enough on the intersection of thirds.

103

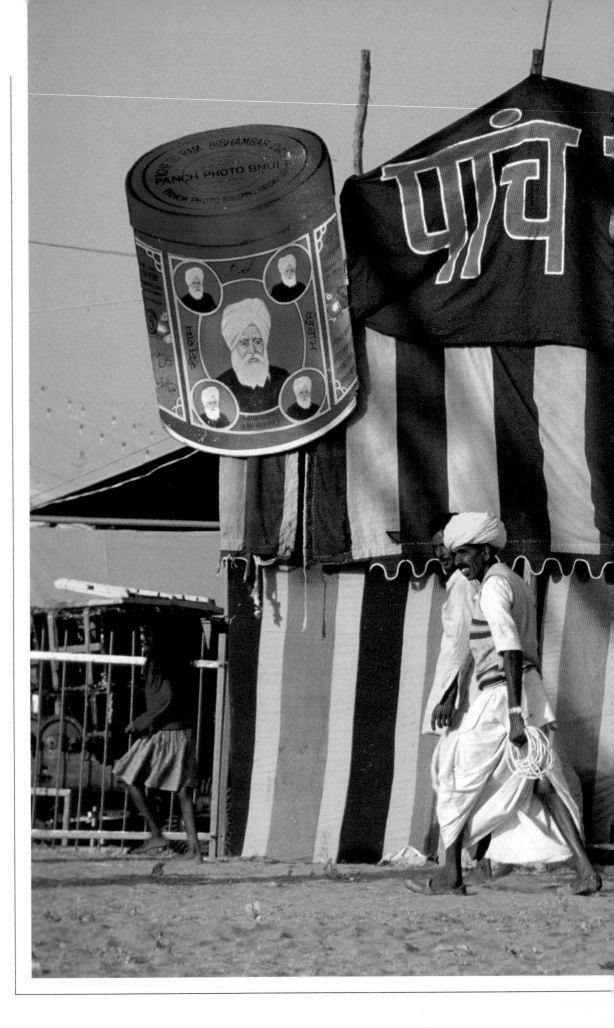

Travel photography

81 Shoot local events

Taking photographs of local events is an excellent way of adding colour and life to your record of a place when you are travelling. The key to successful pictures of such occasions is making sure of a good view, and it helps to do a little research beforehand so that you know exactly what will happen and where. Arrive in good time, so that you are not restricted in your choice of viewpoints. A long-focus lens is a big asset, as it not only enables you to get tightly framed shots from a distant viewpoint, but also has the potential to throw fussy background details out of focus. Something to stand on can be a big advantage; press photographers carry step ladders, but a stool or hard camera case can make a big difference. Don't overlook the possibilities of good people pictures among the crowd of onlookers.

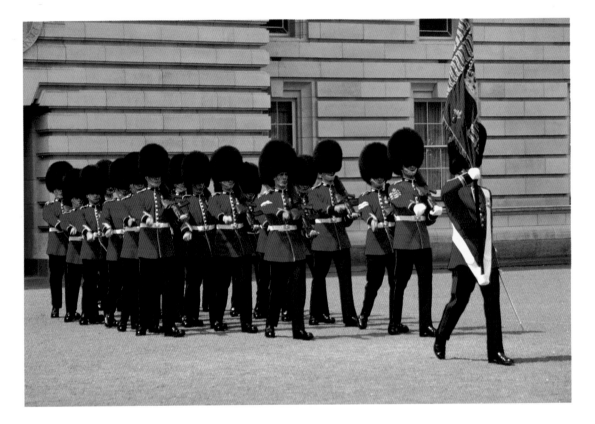

Changing of the guard

first view This was my second attempt at photographing the changing of the guard at Buckingham Palace in London. On the first occasion I could not get close enough to the front of the crowd to have any chance at shooting anything worthwhile, although I'd thought I had arrived in good time.

in camera On my second visit I arrived so early that I was almost the only person there at first. The first attempt was not wasted, though, as I'd had a chance to watch what happened and had a good idea of where I wanted to be. My choice of viewpoint was based not only on having a clear view of the proceedings but also on where would be best for the lighting and background.

35mm SLR camera; 70–200mm zoom lens; Kodak Ektachrome 100SW

82 Photograph a market

A market is a great place to capture local colour and to take photographs of people and produce. There's something about it that seems to make people more relaxed than usual, and it is much easier to take photographs of strangers when they are preoccupied in some way. Don't rush to take photographs, but take time to familiarize yourself with the scene and let your potential subjects become accustomed to your presence. It helps not to look too much like a serious photographer. I like to carry spare film and lenses in a pocket and leave my big camera bag behind. It is also only polite to compliment the stallholders on their produce, and perhaps buy some of it, if you want to take photographs of the displays. Choose an overcast day when the light is soft, look for subjects in areas of shade, or shoot into the light.

Ahamadabad market

first view At a market like this one, in the Indian city of Ahamadabad, a photographer is almost spoilt for choice, because the produce is so interesting and colourful, and it is displayed to perfection. The people here were also very friendly and co-operative. Although it was a bright sunny day most of the stalls were shaded in some way, which greatly improved the lighting quality. I particularly liked this man's display, with the large basket of very photogenic baby eggplants in the front.

in camera Using a wide-angle lens, I chose a close viewpoint, slightly to the right of the stall, so that the line of baskets created a zig-zag. I stood on tiptoe so that I could shoot down on the foreground vegetables. I was hand-holding the camera, so I had to strike a compromise between a fast enough shutter speed to ensure a sharp image and a small enough aperture to give me good depth of field.

35mm SLR camera; 24–85mm zoom lens; Kodak Ektachrome 100SW

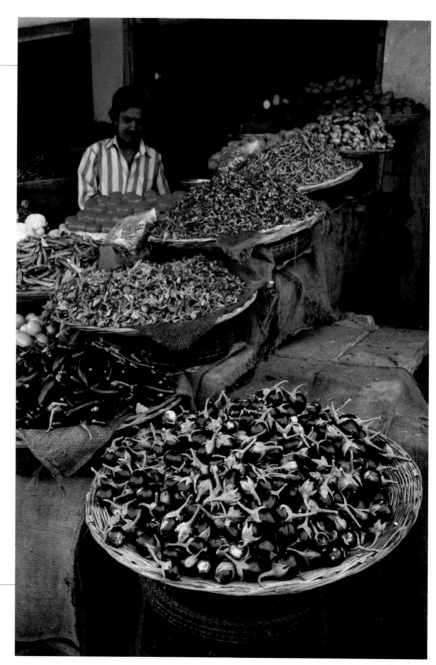

83 Focus on architectural details

An evocative way of identifying a country or region, and of describing its culture, is to shoot close-up images of architectural features. Even a relatively insignificant detail can not only create a satisfying and eye-catching image, but also say a great deal about a people's heritage. Images like these depend a great deal on their basic visual elements, and features with interesting shapes, textures and patterns are likely to produce the most satisfying photographs. Lighting is important and the diffused light of a cloudy or overcast day is better for revealing subtle details and textures than direct sunlight. For maximum impact, it is necessary to fill the frame with the most striking elements of the subject, so you are likely to need a long-focus lens and a firm tripod.

Indian column

first view I took this picture on a visit to Fatephur Sikri in India, a curious hilltop town built in the 16th century as the capital of the Moghul Empire. After a relatively short period it was abandoned because of lack of water. It is full of beautiful buildings with intricately carved decorations and has a strange, unworldly atmosphere. On a previous visit I had been blessed with good light, which enabled me to shoot some of the buildings in their entirety. This time the sun was in the wrong position and the sky was hazy, so I decided to concentrate on some closer details.

in camera This particular feature was at the top of a column supporting the roof of a temple open to the daylight. The quality and direction of the diffused light created such good detail and interesting texture that I felt the most effective shot would be to frame this relatively small feature quite tightly. I set a small aperture to ensure good depth of field and made my exposures with the camera mounted on a tripod.

35mm SLR camera; 24–85mm zoom lens; Fuji Velvia

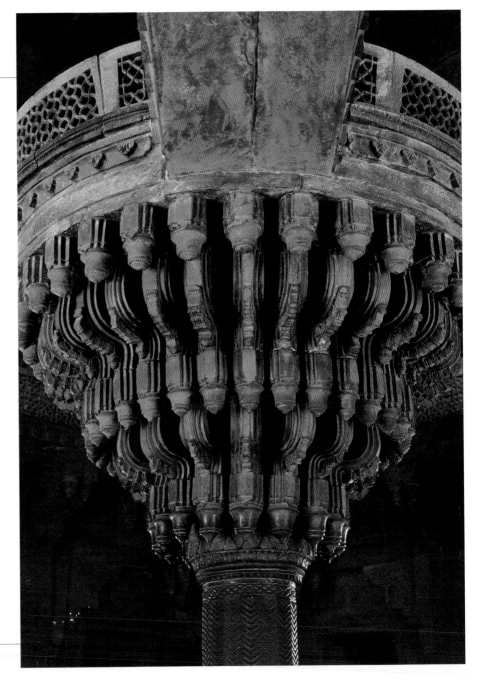

84 Photograph local crops and produce

An important aspect of travel photography is finding subjects that help to identify a particular country or region, as well as creating images that are colourful and interesting. It is often possible to achieve this very effectively by photographing the most characteristic crops of an area. For instance, a field of sunflowers or lavender is often chosen to represent France, and in a similar way subjects as diverse as rice paddies, olive groves, fishing boats and grape vines can all help to link a photograph with a particular location. It's not only the crop or produce, but the way it is cultivated, harvested and processed that may be characteristic of the country, and images of traditional agricultural methods make eye-catching and informative photographs.

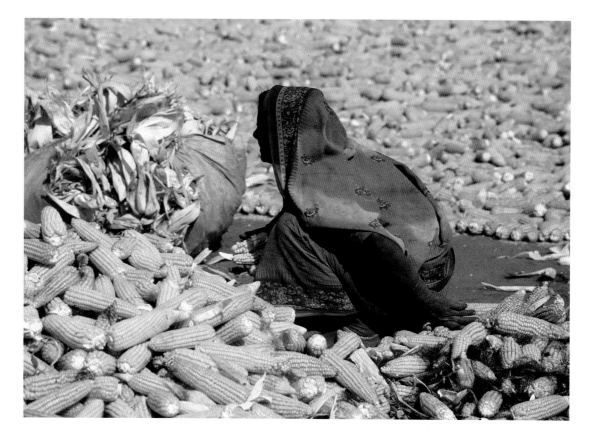

Maize lady

first view Driving through India presents you with a series of astonishing sights every day. When I saw this huge area of ground covered with ears of maize drying in the sun it practically took my breath away. It was a bright sunny day and the light was very contrasty, which was not ideal for recording the colour.

in camera My first attempts at photographing the scene were based on showing the vast expanse of the harvested crop using a wide-angle lens, but I was not totally happy with these as the sunlight caused the ears of maize to glare, and the image seemed too harsh. In the end I decided I would do better to use a long-focus lens and frame a much smaller area of the scene more tightly, using an individual worker as a focus of interest.

35mm SLR camera; 70–200mm zoom lens; Fuji Velvia

85 Shoot informal portraits

Photographing people while travelling can add a great deal of interest and value to a record of a trip. While candid shots of local people can be fun, it can be more satisfying in the long term to take a little more care and shoot some portraits that say more about individual people than they do about their background or setting. I like to shoot candid pictures of people, but I also like to have the extra control that is possible when you ask permission and have the co-operation of your sitter. Bear in mind, too, that eye contact can have a powerful effect in a portrait. It's best to find a background that will not be distracting and will help to make your subject stand out clearly. You need to make sure that he or she is comfortable and relaxed, and also to find a place to take your pictures where the lighting is sympathetic.

Indian merchant

first view I met this man in a market in the Indian city of Jaipur. He'd been watching me for a while as I was taking photographs, and I think he was rather amused by my enthusiastic camera wielding. I know many people are daunted by the thought of asking a stranger if you can take their photograph, but I've been doing it for years now and, although I've had the very occasional polite refusal, I've never had a bad moment. This man agreed very readily, in fact I think he'd been waiting to be asked.

in camera The sunlight was harsh where he was standing, so I asked if he would move into the shade and found a spot where the background was plain and uncluttered. I often ask people to sit down for a portrait, so that I can shoot slightly down on them, but in this case I thought that the slightly low viewpoint suited his noble expression and composure.

35mm SLR camera; 70–200mm zoom lens with extension tube; Kodak Ektachrome 100SW

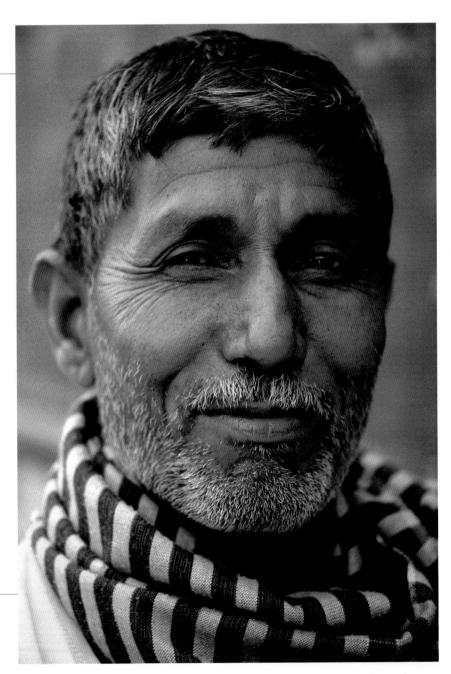

86 Photograph transport

Modes of transport of all kinds are an essential aspect of travel, and for a photographer the journey can provide subjects that are just as interesting as the destination. Many vehicles are also characteristic of a particular region, and can furnish striking pictures that reveal a facet of the lifestyle and culture of a country. When you consider the variety of ways and means of getting from A to B, ranging from gondolas in Venice to rickshaws in Asia, cable cars in San Francisco, camels in Africa and elephants in India, you realize just how enterprising we humans can be. There are many different approaches to be considered, from close-up, still-life images of vehicles and equipment, to action shots, station architecture or pictures of your fellow passengers. I've always found railway lines and stations rather fascinating.

Gare du Nord

first view Since giving up my studio in London, and the need to commute, I rarely travel by train, and what was once a chore is now rather fun. My wife, Pat, and I recently went to Paris for a long weekend and travelled by Eurostar. It was such an enjoyable experience and so comfortable that, unlike air travel, the journey itself provided very happy memories of the trip. I was keen to record this in some way but the weather was poor and the light made it impossible to take satisfying shots of the train in daylight.

in camera Our return trip was due to leave the Gare du Nord just as it began to get dark, and when we arrived at the station the lights had already been switched on. The sky had become just dark enough to make the lamps glow, but there was still sufficient daylight to prevent the shadows becoming too dark. I'd not packed my tripod so I found a viewpoint where I could brace the camera against a support and have a good view along the platform. I framed the image to exclude the areas that were not well lit and to allow the big windows to fill the frame.

35mm SLR camera; 24–85mm zoom lens; digital capture at ISO 400 setting

87 Photograph shop windows and advertising

Among my many photographic obsessions is a liking for shop windows and advertising signs. I not only find them quite fascinating but also think they can make striking images. Wherever I'm travelling I keep a lookout for good examples, and in countries like India and Africa they can often be quite bizarre and spectacular. Pictures like these are something you can build up over time into an interesting collection. Like any images that record contemporary styles and tastes, they have a value that increases with the passing of time. Even pictures taken of these subjects in the sixties and seventies are already quite fascinating, as nostalgia for yesterday's fashions cuts in. Little skill in composition is usually needed, since taking these pictures is often just a case of shooting square on and filling the frame, but it can sometimes be effective to incorporate other elements, including window shoppers.

Art gallery

first view I spent a few days in Brussels a while ago, a city I'd never visited before, and liked it very much. In an area where many art galleries are concentrated I became interested in some of the window displays. Shop windows are, in essence, a piece of design, and the windows of art galleries are often especially striking. This one had a distinctly minimalist approach which appealed to me, but I felt that it needed rather more to make a satisfying picture.

in camera A few people had stopped beside me to look at the window display, and I stepped back and decided to wait a while to see if this might be the extra element I needed. This man did more than just stop and look, he seemed mystified by the meaning of the piece of art and spent just long enough, seemingly, to fathom why anyone would want to buy it, for me to move quickly into position and make my exposure.

35mm Rangefinder camera; 28mm lens; Fuji Provia 100F

88 Look for a different angle

When visiting famous buildings and monuments, it's very easy to photograph them from the viewpoints that are familiar. These viewpoints are often the most readily accessible, and they usually show the building most effectively. It's uncommon, for example, to see a picture of the Taj Mahal from anywhere other than over the water leading up to it: the terrace from which those pictures are taken is always crowded. But when you see a shot from a different angle it invariably stands out. One way to get an original picture is to look for a contrived angle, where you can create an exaggerated perspective or introduce some unusual foreground features, but you can often produce a less familiar image by moving much further away and including more of the building's setting. A good tip is to stand in front of the place you want to photograph, look at the surroundings and try to locate an accessible spot from where you might be able to shoot.

Château of Chambord

first view This French château is one of the grandest in the Loire valley, and is very big and imposing. There are numerous viewpoints immediately in front of the building from where you can photograph it, but the château is set in the middle of a beautiful park, and I was interested in finding a way of showing the building within its setting, rather than taking a straightforward architectural picture. I'd already taken some shots close to the building and while doing so had noticed that there was an access road some distance away at the end of a tree-lined drive.

in camera It was early autumn, some leaves had fallen and the sun was beginning to head towards the horizon, creating an element of mood. Using a wide-angle lens I found a viewpoint from where I could include a large area of fallen leaves, and framed the image so that the smallest area of shaded trees on the left was included and the château was placed off centre.

Medium format SLR camera; 50mm shift lens with neutral-graduated and 81A warm-up filters; Fuji Velvia

89 Shoot evocative details

If you want your pictures to establish the identity of a place you've visited, the easiest, and most obvious, way is to photograph a well known building or landmark, such as the Opera House in Sydney. But it is possible to do this in a more subtle way, by looking out for details that achieve the same effect, such as shop signs, modes of transport, architectural styles and regional dress. Such pictures are often more enjoyable to photograph and more entertaining to look at, and help to avoid the more clichéd approach to recording a particular region. A series of images like these will very often capture the atmosphere and character of a location more effectively than a single, instantly recognizable picture of a famous landmark.

Lobster floats

first view It's funny what strikes you most when you visit a place for the first time. On my initial trip to the coast of Maine in New England I became almost obsessed by lobster floats. Lobster fishing is a major industry in this region, and I was told that the floats are a way of identifying which pots belong to whom. They are painted in every colour and design imaginable and were, for me, an irresistible subject. Even now, they conjure up Maine for me more strongly than anything else I photographed there.

in camera I must admit to photographing very many lobster floats during my two weeks in Maine, but this is one of the pictures I like best, because of its very haphazard arrangement and wonderful mixture of colours. It was a dull day and the light was soft, which has made the colours even stronger. I simply chose a frontal viewpoint and framed the image so the most interesting part of the collection filled the viewfinder.

35mm SLR camera; 70–200mm zoom lens; Fuji Velvia

90 Photograph a sunset

Few people can resist taking photographs of a sunset, but many are disappointed with the result. One reason is that a straightforward exposure reading results in the photograph being too dark, because the sky near the sun is so much brighter than anything else. This can be avoided by taking a reading from a point well above or to one side of the brightest part of the sky. Second, even when the exposure is correct for the sunset, foreground details will be underexposed. This can be overcome by using an interestingly shaped foreground object as a silhouette, or by finding a reflective foreground such as water. A neutral-graduated filter will help to balance the difference in brightness between the sunset and the foreground.

Mississippi sunset

first view I was lucky enough a few years ago to be invited to travel on one of the Mississippi steamboats in order to write an article for a travel magazine, and it was a very enjoyable and unusual experience. But, as with many cruises, more time was spent on board than on shore, and there were many potentially great picture opportunities that I could see but not photograph. Getting a good shot of the boat was very important but difficult to achieve, as there was little time available while embarking and disembarking, and the surroundings or lighting where the boat was moored were often not very inspiring.

in camera This was one of my few chances. We had spent the day visiting the small city of Baton Rouge and returned to the boat at the end of the day. There was a raised bank above the boat's mooring that enabled me to find a viewpoint showing the bridge and river, as well as providing a good view of the boat. I had to wait while some of the strength went out of the sun, and adjusted my viewpoint so that the brightest area of the sky was masked by the bridge. I used a neutral-graduated filter to reduce the brightness of the sky further.

35mm SLR camera; 35–70mm zoom lens with neutral-graduated filter; Fuji Velvia

Landscape photography

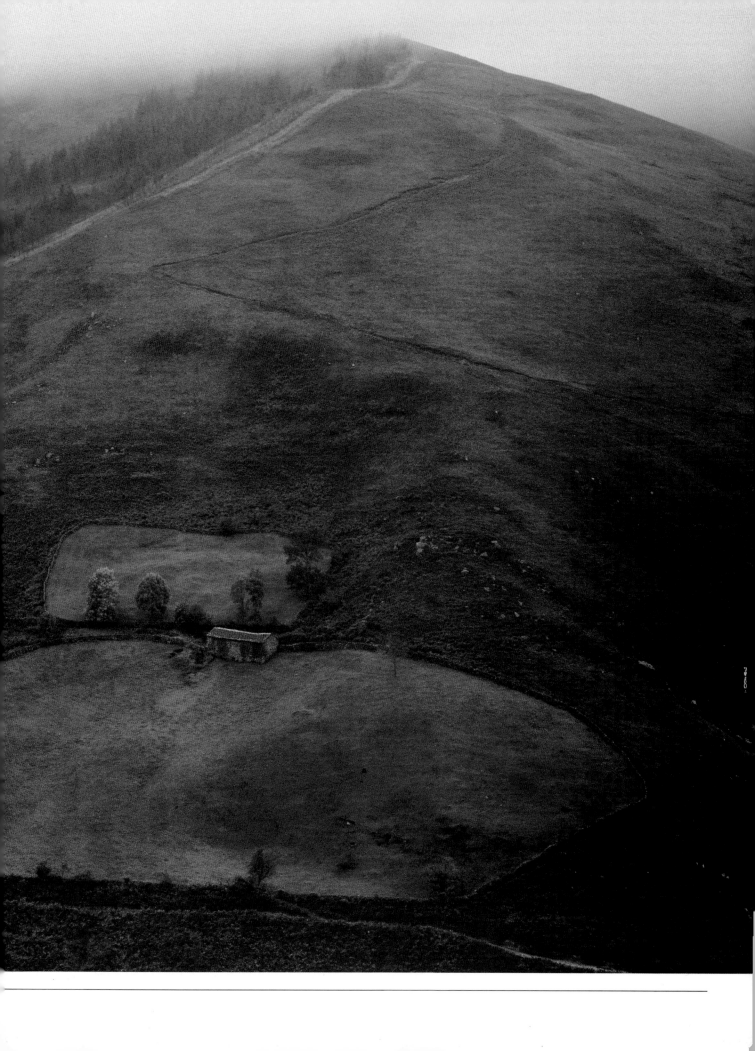

91 Choose the right time of day

One of the most enjoyable, fascinating but often frustrating things about photography is the continually changing relationship between light and the subject it illuminates. In no area is this more ephemeral than in landscape photography. It's quite possible to see a potentially stunning image one moment, only to find it has gone a minute later. You may just happen to be in the right place at the right time, but good luck has a better chance if you help it along with a little planning. Some of the best landscape photographs have been the result of establishing a viewpoint through careful research, and then waiting for the ideal lighting conditions before taking the photograph. But even if you don't go to these lengths it's still possible to give yourself a much better-than-average chance of success by being aware of the possibilities.

Monument Valley

first view I'd planned to arrive at Monument Valley in Arizona in the late afternoon, to make use of the low-angled evening light, only to find that the site was closed for the day. This was frustrating, as I could see from the access road that there were some great opportunities, but beyond my reach. I'd intended anyway to return next morning but that was now my only chance.

in camera Early next morning I could see that I had missed some great chances. One classic view of the valley, made famous by John Wayne's movies, would only have worked in evening light and now appeared to have no photographic potential at all. But, with this type of landscape in particular, for every picture you miss in the evening light another becomes possible in the morning. This photograph was a good example, as even an hour or two later the lighting on the rock formation would no longer be attractive.

35mm SLR camera; 24–85mm zoom lens with polarizing and 81A warm-up filters; Fuji Velvia

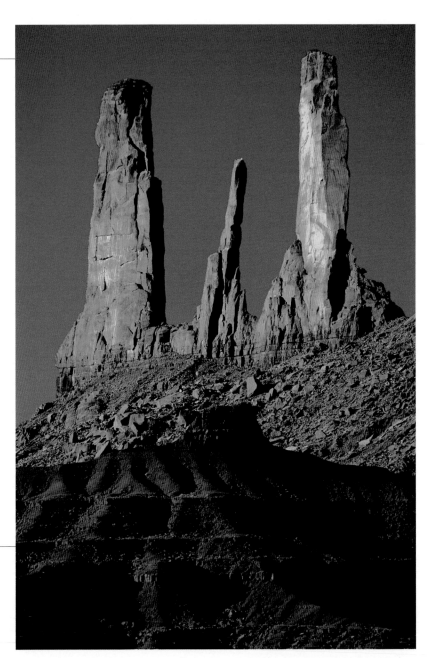

92 Shoot seascapes in all conditions

Sky and water have a wonderful affinity. The changing sky reflected in the sea creates a constant interplay between light, shade, tone and colour that offers a wealth of picture opportunities. A day by the sea can be an exhilarating time for photography, from picture-perfect conditions of blue sky and white clouds, to the bleak atmosphere of out-of-season holiday resorts and dark, stormy skies, when a seascape can become very dramatic indeed. Seascapes can be at their most interesting on days when the the lighting conditions are unsatisfactory for subjects such as landscapes and buildings. When shooting landscapes, a lack of contrast can become a problem when the sky is overcast and the lighting is too soft to create strong shadows. But because of the reflective qualities of water it can be used to raise the contrast of a scene, with the ability to create strong highlights from even a slightly lighter tone in the sky.

Indian Ocean

first view I shot this image while travelling by boat in the Maldive Islands. A big storm was brewing and we headed for a safe haven inside the reef. Here the much shallower, calmer water took on this beautiful translucent quality, and the contrast with the inky ocean beyond and the threatening sky was very striking.

in camera There was no obvious focus of attention, which I felt was needed. I'd provisionally framed my shot and fitted a neutral-graduated filter to maximize the dark tones of the sky when I noticed some waves breaking on the coral. By altering the camera angle and reframing the image I needed only to wait for a good bright wave to break before shooting.

35mm SLR camera; 35–70mm zoom lens with polarizing and neutral-graduated filters; Fuji Velvia

93 Establish a sense of scale

It's not always possible to determine a true sense of scale in landscape photographs unless you make a conscious effort to indicate it. You can usually find something to suggest it, and when an image contains objects or details that show the scale of the scene in a dramatic way it invariably creates a considerable degree of impact. One of the most striking ways in which you can indicate scale is to include a human figure, but any object that the viewer will know the approximate size of will also be effective, such as a cottage or a tree. The key factor is that the object should be shown in true proportion to the landscape in which it is placed, and this means that it should be at a similar distance to the scene you are photographing. The impact will be considerably increased when a small area of landscape is isolated with a long-focus lens.

Plain of Champagne

first view I'm especially fond of this part of France, where the grapes for champagne are grown, because of the wonderful patterns formed by the cultivated fields, which can look so different at each season of the year. The land is very flat but there is a steep hill where the vines are grown that I always climb, if I'm nearby, for the great view it provides over the countryside.

in camera From this viewpoint, with a long-focus lens, you can render the scenery as an almost abstract pattern with a very flattened perspective. On this occasion I was deciding how best to angle the camera and frame the image when I saw this truck approaching from the distance, with its billowing cloud of dust. I repositioned my camera when I saw where it was heading and waited until it was in the right spot before shooting.

35mm SLR camera; 70–200mm zoom lens with x 1.4 converter; Fuji Velvia

94 Exclude the sky

When taking landscape photographs it seems quite natural always to include the sky, but excluding it can sometimes greatly improve a picture. When the sky is weak and pale, such as on a hazy summer's day, it will not only have no visual interest but will also be much lighter than the rest of the scene, and this will detract considerably from the impact of the landscape. When a large area of pale sky is included it can also result in underexposure and will tend to reduce the contrast and colour saturation of the foreground. Even when the sky is blue it can be a mistake to include more than a narrow strip unless it is enlivened by some nice white clouds. It's wise always to consider just how much the sky is contributing to the picture: unless it looks interesting, or there are important details above the horizon, it's often better to leave it out.

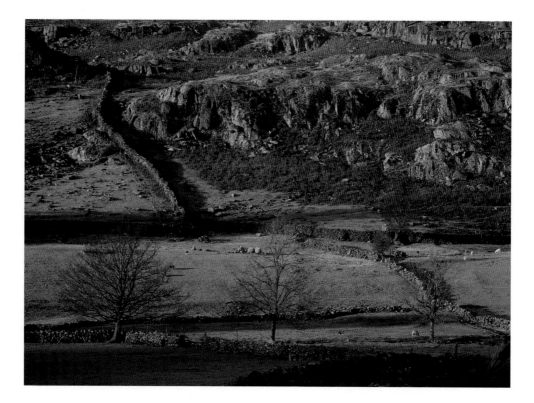

Dunnerdale

first view The small valley of Dunnerdale in Cumbria is one of my favourite places in England. On this occasion, in midwinter, the bracken had taken on a vivid hue. It was a bright sunny day and the sky was a deep blue, but I was especially interested in the rich colour and texture of the steep hillside and the pattern created by the drystone walls.

in camera I found a viewpoint that placed some trees in the middle distance, with a shadow in the immediate foreground, to help focus attention on the hillside. When I started experimenting with the framing I included a small area of sky. This looked quite good but I realized that the addition of blue at the top of the image pulled the eye away from the elements I was most interested in. It also necessitated including more than I wanted of the scene at each side, so I reframed the shot to exclude it.

Medium format SLR camera; 105–210mm zoom lens; Fuji Velvia

95 Shoot winter landscapes

Many photographers prefer to go out looking for pictures when it is warm and sunny, but some of the best landscape opportunities occur during the winter months, and this time of the year can be very rewarding. One advantage is that the sun is at a low angle all day and consequently has a warm, mellow quality, making warm-up filters largely redundant. The atmosphere is clearer and the sky bluer, and you can often photograph distant views with maximum clarity and definition. In addition, the landscape itself can be more interesting during the winter, because bare trees have a much stronger visual quality and freshly ploughed fields create a dynamic textural element. There is also, of course, the possibility of interesting weather conditions, including fog, frost and snow, to add an extra dimension to your pictures.

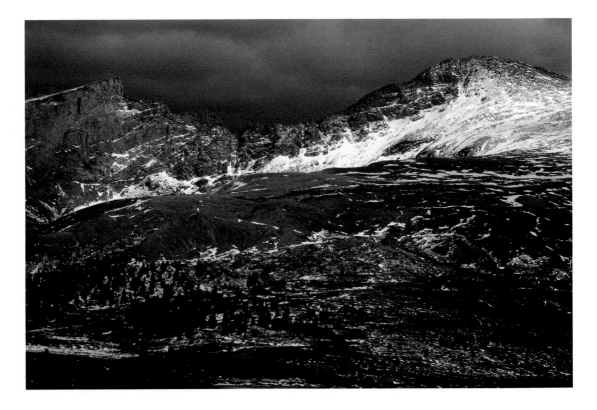

Colorado Rockies

first view Having spent a couple of warm sunny days in Denver in spring, with the trees coming into leaf, as I drove up over one of the mountain passes heading south it was a shock to discover that it was still very much the middle of winter here, and had just started to snow. This was the scene that confronted me at the summit of the pass: the dark, thunderous sky, the dappled sunlight on the mountain and the strongly textured landscape made a combination that I found pretty irresistible.

in camera At first I began looking for viewpoints that would allow me to use a wide-angle lens and include some foreground details. However, as the sunlight became stronger on the mountainside and the sky became darker still, I felt increasingly that this was the essence of the scene. I switched to a long-focus lens to enable me to isolate just this area of the landscape.

35mm SLR camera; 70–200mm lens;
Fuji Velvia

96 Use a lead-in

One of the most attractive qualities a landscape photograph can have is the ability to draw the viewer's eye into a scene, so that he or she can imagine being in that place and walking into it. This not only makes the image more visually appealing, but also enhances the impression of perspective and helps to create a sense of depth and distance. I have a special fondness for using paths or roads in this way, but a similar effect can be created by using any strong line that leads away from the camera, such as a line of trees or the furrows in a ploughed field. The effect will be especially striking when you use a wide-angle lens so that the beginning of the lead-in is close to the camera, but it can still be an effective device when longer focal lengths are used and the scene is more distant.

Gascon landscape

first view The French region of Gascony is delightful in high summer, when the weather is hot and sunny and vast fields of sunflowers cover the rolling landscape. Its greatest charm for me, though, is the unhurried and peaceful rural atmosphere and the feeling of being away from it all. I'd already taken a few sweeping views and some shots of sunflower fields when I saw this farm track.

in camera This track was especially appealing because its light colour made it stand out so boldly, and because it led directly away from the camera and disappeared. My first thought was to use a closer viewpoint with a wide-angle lens to accentuate the perspective but this meant including elements of the scene which I thought would be distracting. When I looked at it through a long-focus lens I liked it much more, as it emphasized the hot hazy mood of the scene and the inviting quality of the track.

35mm SLR camera; 70–200mm zoom lens with 81B warm-up filter; Fuji Velvia

97 Include foreground interest

One thing that almost always adds both interest and impact to landscape photographs is the inclusion of foreground details, especially when the picture is of a distant scene. When all the objects in an image are some distance away from the camera, the picture will lack a sense of depth and distance and will appear flat and lacking in perspective. In many cases, a relatively insignificant object in the foreground can be used to overcome this, such as some grasses, a stone wall or a field gate. Looking for suitable foreground interest should become part of the process of choosing a viewpoint. When you see a distant scene you want to photograph, it can pay to look behind you as well as ahead, in case there is something you can use in this way.

Lake Kariba

first view This artificial lake in Zimbabwe is so big it seems more like a sea, except for the skeletal remains of drowned trees along its shore. When the chance arose to shoot these at sunset I jumped at it, as I was based on the eastern shore and would have a westerly outlook. It took a while to find a suitable group of trees, and as they were some distance from the shore I began by using a long-focus lens to enlarge them in the frame.

in camera As the sunset developed, a very attractive cloud formation evolved in the sky and I switched to a wide-angle lens in order to include it. This made it seem necessary to include some foreground interest as well. There were some rocks nearby, and I placed the camera quite low so that the nearest rocks were only about 1m (3ft) away. I set a small aperture to ensure that there was enough depth of field and used a neutral-graduated filter to even the balance between sky and foreground. I then waited until a wave broke on the rock before shooting.

35mm SLR camera; 20–35mm zoom lens with neutral-graduated filter: Fuji Velvia

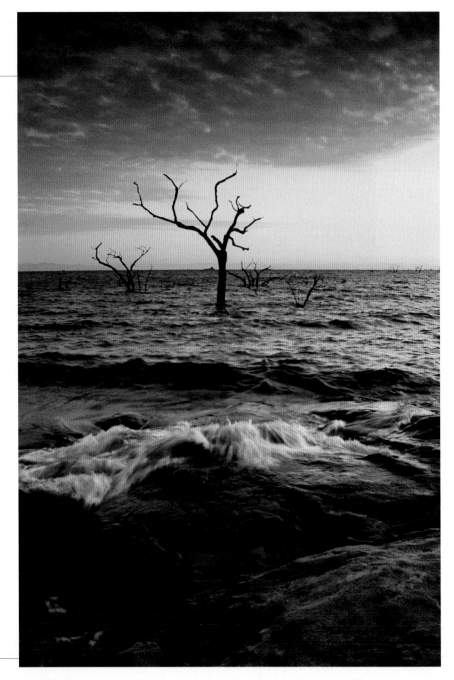

98 Emphasize the sky

While a clear blue or flat, overcast sky is usually best excluded, a picture can be enormously improved by making the most of billowing white clouds or a dramatic stormy sky. Left to its own devices, the sky often records less richly on film than it appears to the eye, because more exposure is usually needed for the landscape than for the sky. Clouds in a blue sky can be emphasized with a polarizing filter, which makes the sky a richer and more saturated blue, and also makes the clouds stand out in greater relief. If the sky is very bright, it can also help to use a neutral-graduated filter, especially when shooting into the light. The latter can also help to convey the drama of a stormy sky, which may otherwise record lighter than it appears.

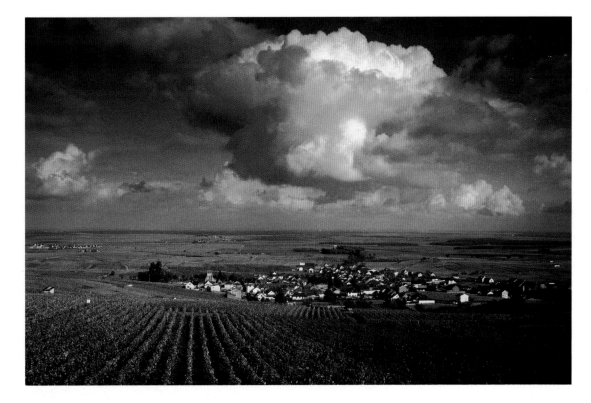

Oger in Champagne

first view Autumn is one of the best times to visit this region of France because of the autumnal colouration of the vines, and also because the light is sharper and clearer than when the hot, hazy summer atmosphere prevails. Initially, my main interest in this scene was the rows of golden-tinted vines leading the eye to the distant village and the far plain beyond, and I had taken a number of shots that concentrated on these elements before I became aware of the rather magnificent sky above it all, and the beautifully shaped cloud that was so well placed.

in camera I was already working with a wide-angle lens, so all that was needed was a slight change of viewpoint and to angle the camera up, sacrificing some of the foreground interest in favour of the sky. I used a polarizing filter to make the sky a richer hue and to help the cloud to stand out in stronger relief. The big cloud was very brightly lit at the edges, and I was concerned that this might be bleached out, so I also fitted a neutral-graduated filter to make it darker.

35mm SLR camera; 20–35mm zoom lens with polarizing, 81A warm-up and neutral-graduated filters; Fuji Velvia

99 Convey movement in a waterfall

A slow shutter speed records moving water with a wonderfully ethereal, smoky quality. You will need to use a tripod, and it's important to include some static elements, such as rocks or foliage, which will be recorded with sharp detail in contrast with the water. An alternative method is to use your camera's multi-exposure setting, which allows you to make, say, eight or sixteen exposures on the same frame, giving each a fraction of the exposure indicated. For example, if your meter indicates an exposure of 1/125 sec at f/8, you give eight exposures of 1/1000 sec, or sixteen of 1/2000 sec, at the same aperture. It's essential, of course, that the camera is not moved until the sequence is complete. Such images are usually more striking when photographed on a cloudy day when the light is soft, or in the shade.

Blue waterfall

first view This is one of numerous waterfalls in a small valley in the Aragon region of Spain. On this occasion, during the winter months, there was a good flow of water. It was a bright sunny day with a deep blue sky, but I chose a waterfall that was in an area of shade so the light would be diffused and there would be no dense shadows or very bright highlights to spoil the soft, smoky quality of the water.

in camera The reflected light from the blue sky was giving the water a bluish tint. I could have corrected this by using a warm-up filter, but I felt that it added to the atmosphere of the scene and allowed the colour cast to remain. I chose a viewpoint and framed the image so the water filled the frame, and set an aperture that enabled me to use a shutter speed of 1 sec.

Medium format SLR camera; 55–110mm zoom lens; Fuji Velvia

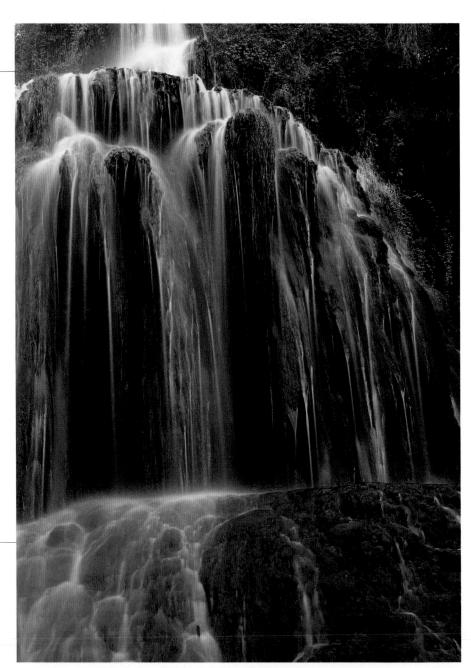

100 Shoot in bad weather

Most photographers prefer to spend a day out shooting pictures when the sun is shining and the sky is blue, and these conditions will almost certainly guarantee a measure of success with the right subject and good composition. But there is much to be said for choosing a day when the weather is bad as, although there may not be so many opportunities, images shot under these conditions invariably have a more striking quality. Conditions such as fog, snow and rain can transform both town and countryside, and often produce pictures with greater mood and atmosphere than those taken on a sunny day. You need to be aware that both fog and snow can make a scene seem brighter than it actually is, so underexposure is a risk. It is best to take a close-up or spot reading from a mid-tone in the subject.

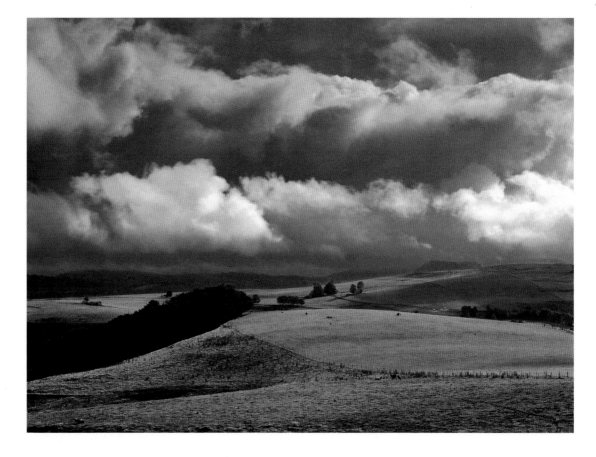

Auvergne

first view The weather in France's Massif Central tends to be quite volatile, and I've experienced some of the most spectacular storms and dramatic skies I've ever seen while travelling there. For me, the most exciting conditions in which to take landscape photographs are when there is a really dark stormy sky, with gaps through which the sunlight can sometimes find a way.

in camera I'd found a viewpoint that gave me a sweeping view of both the landscape and the sky, and I could see that the sun might light up the area I wanted. I had to wait a while before this happened and, although I had framed my image in readiness, the position of the illuminated areas made it necessary to change the composition at the last moment. The brightness lasted for only a few seconds.

Medium format SLR camera; 105–210mm zoom lens with neutral-graduated filter; Fuji Velvia

Index